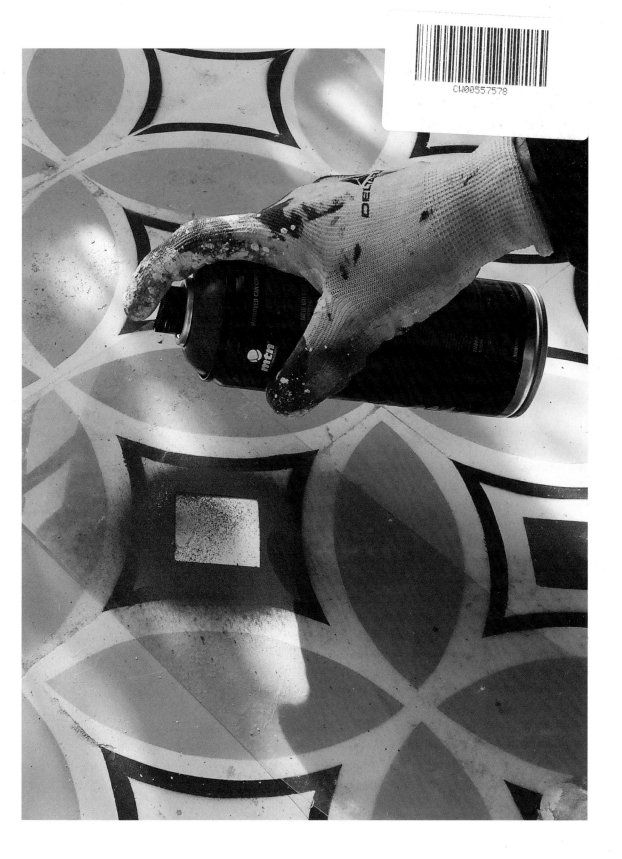

HandMade
Graphics

Copyright © 2016 Instituto Monsa de Ediciones

Editor, concept, and project director
Josep María Minguet

Co-author
Carolina Amell

Art director, design and layout
Carolina Amell
(Monsa Publications)

Cover design
Carolina Amell
(Monsa Publications)

INSTITUTO MONSA DE EDICIONES
Gravina 43 (08930)
Sant Adrià de Besòs
Barcelona (Spain)
Tlf. +34 93 381 00 50
www.monsa.com
monsa@monsa.com

Visit our official online store!
www.monsashop.com

Follow us on facebook!
facebook.com/monsashop

ISBN: 978-84-16500-22-2
D.L. B 6973-2016
Printed by Indice

BY CAROLINA AMELL

HandMade
Graphics

monsa

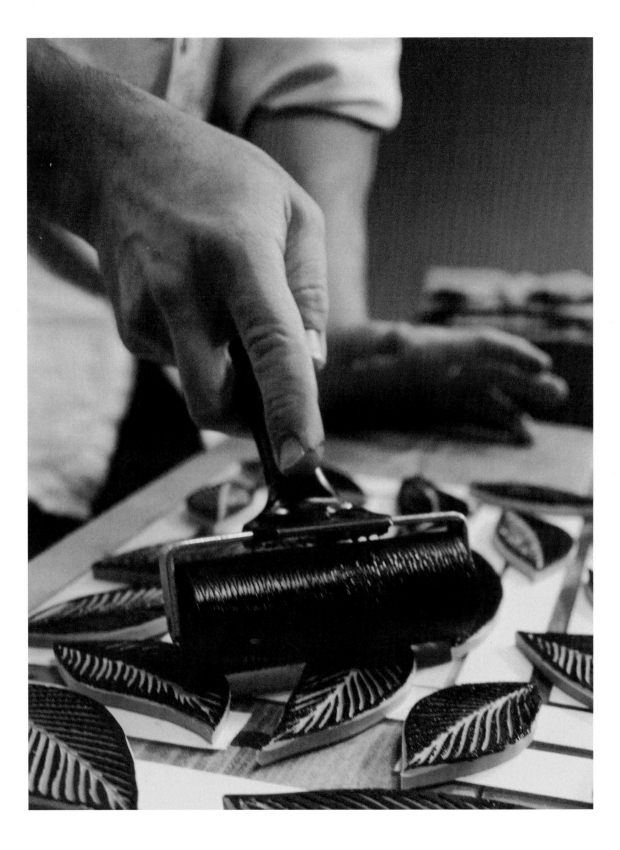

INTRO

"Reinvent yourself or die" it is something that has always been said.

We believe that a very good way of reinventing oneself is coming back to most basic, to research graphic design from the beginning, when it was always made by hand.

It seems incredible that in the times we live in, where technology is a basic work tool for everybody, there are artists who manage to make us drop our jaws with their handmade works.

These new creations manage to give a push to the image creating process, awakening the artist, who researches and creates submerged in a state of latent art, moving away from technology and getting his hands dirty.

From drawing and paintings to 3D graphics with unusual materials, fantastic paper or collage creations..., you will find a wide range of handmade projects that demonstrate that there are no limitations, that it is the moment to reinvent the traditional methods and to break all the rules throughout the creative process to achieve unique results.

We have put together a selection of international artists who have very different abilities among themselves, and who have a common connection linking them together, their great creative force. Their magnificent projects are a source of inspiration for designers of every discipline!

Siempre se ha dicho aquello de "reinventarse o morir...".

Una muy buena manera de reinventarse creemos que es volviendo a lo más básico, investigar desde los inicios de los diseños gráficos cuando siempre estaban hechos a mano.

Resulta increíble que en los tiempos en los que vivimos, en los que la tecnología es una herramienta básica de trabajo para todo el mundo, haya artistas que consigan dejarnos boquiabiertos con sus trabajos hechos a mano.

Estas nuevas creaciones consiguen dar un impulso al proceso de creación de imágenes, despertando al artista que investiga y crea sumergido en un estado de arte latente, alejándose de la tecnología y ensuciándose las manos.

Desde el dibujo y la pintura a gráficos en 3D con materiales fuera de lo común, fantásticas creaciones de papel o de *collage*..., encontrareis una amplia gama de proyectos hechos a mano que ponen de manifiesto que no existen las limitaciones, que es el momento de reinventar los métodos tradicionales, y romper todas las reglas a lo largo del proceso creativo para conseguir resultados únicos.

Hemos hecho una selección de artistas internacionales con habilidades muy distintas entre ellos y con un nexo de unión en común que es su gran fuerza creativa. Sus magníficos proyectos son fuente de inspiración para los diseñadores de todas las disciplinas!.

INDEX

Pablo Salvaje

www.pablosalvaje.com

Pablo Salvaje doesn't work with his hands. Pablo Salvaje works with the heart.

Born in Seville where he studied Scenic Art and Interpretation, he combined his acting career with his passion for ink, paper and illustration. Since his childhood he was always in contact with the printing world and with the noise of the huge machines that printed at a dizzying speed in his family´s old printing house.

Pablo is a traveller and researcher from birth. In order to keep on deepening his knowledge of the printing techniques, in 2013 he moved to Barcelona where he currently lives and established La Selva Bcn studio with other artists, a creative space where he carries out the workshop instructor task, something that enables him to bring the manual printing art closer for all sorts of people.

He finds in Nature his sources of inspiration; in the trunks, leaves and stones he gathers, there is always a memory, a story that can only be told through his stamps.

Pablo Salvaje no trabaja con sus manos. Pablo Salvaje trabaja con el corazón.

Nacido en Sevilla, donde estudió Artes Escénicas e Interpretación, compatibilizó su carrera como actor con su pasión por la tinta, el papel y la ilustración. Desde pequeño siempre estuvo en contacto con el mundo de la estampación y el ruido de enormes máquinas que imprimían a velocidad de vértigo en la antigua imprenta de su familia.

Pablo es un viajero e investigador nato. Para seguir profundizando en las técnicas de grabado, en 2013 se trasladó a Barcelona, donde actualmente reside y funda con otros artistas el estudio La Selva Bcn, un espacio de creación en el que ejerce la labor de tallerista, permitiéndole acercar el arte de la estampación manual a toda clase de público.

Encuentra en la Naturaleza sus fuentes de inspiración; en los troncos, hojas y piedras que recoge, siempre hay un recuerdo, una historia que sólo puede ser contada a través de sus sellos.

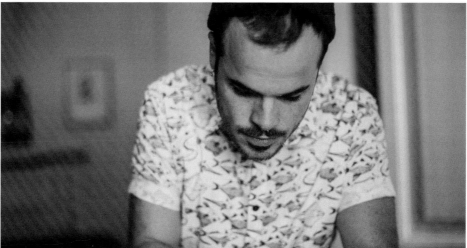

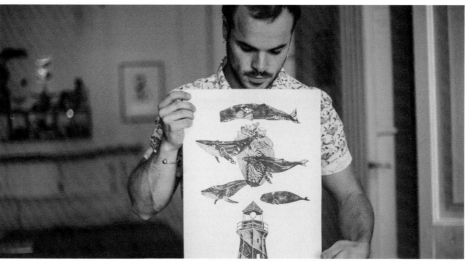

Pablo Salvaje

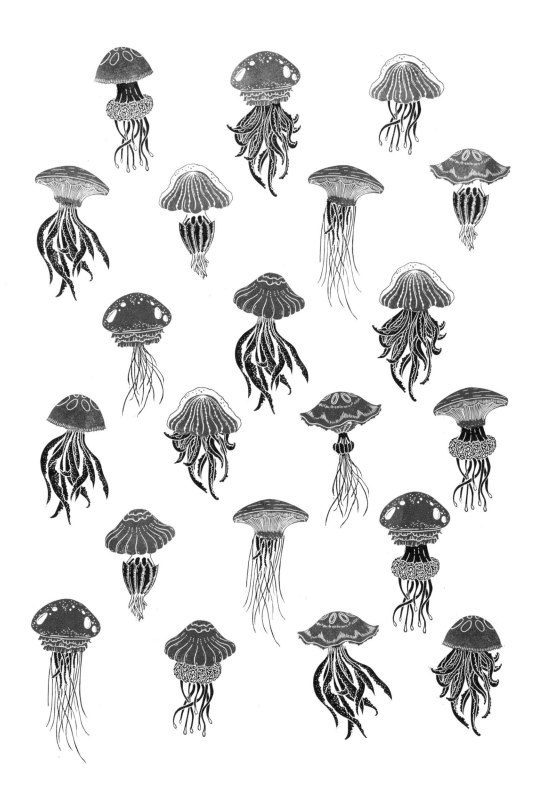

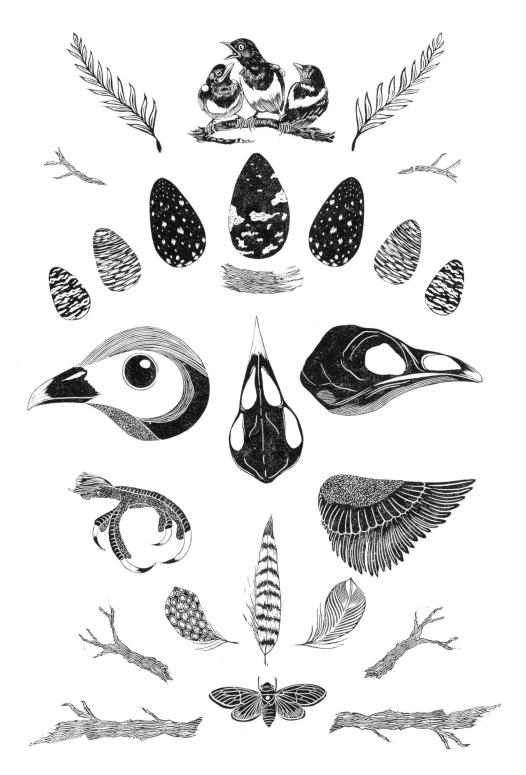

left: Medusas & Algas, Pablo Salvaje / right: Pájaros, Pablo Salvaje

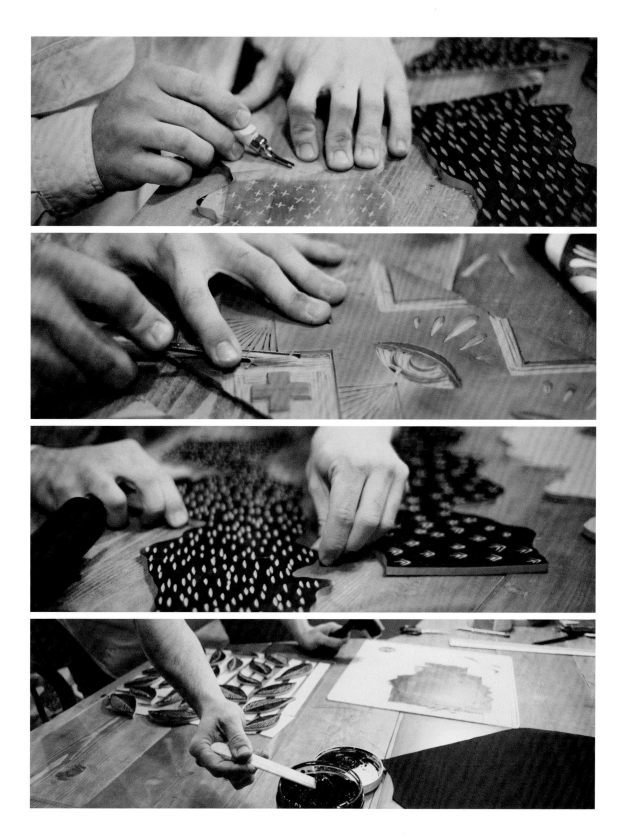

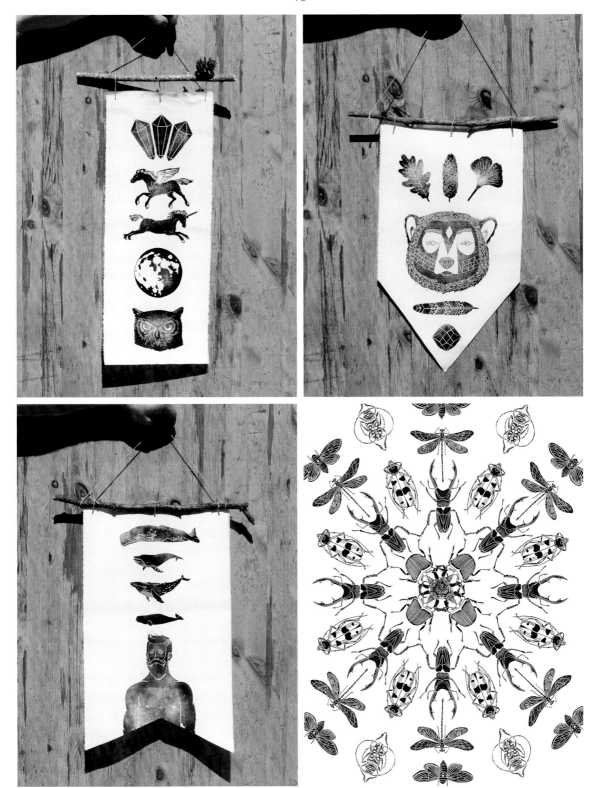

Insectoscopio, Pablo Salvaje

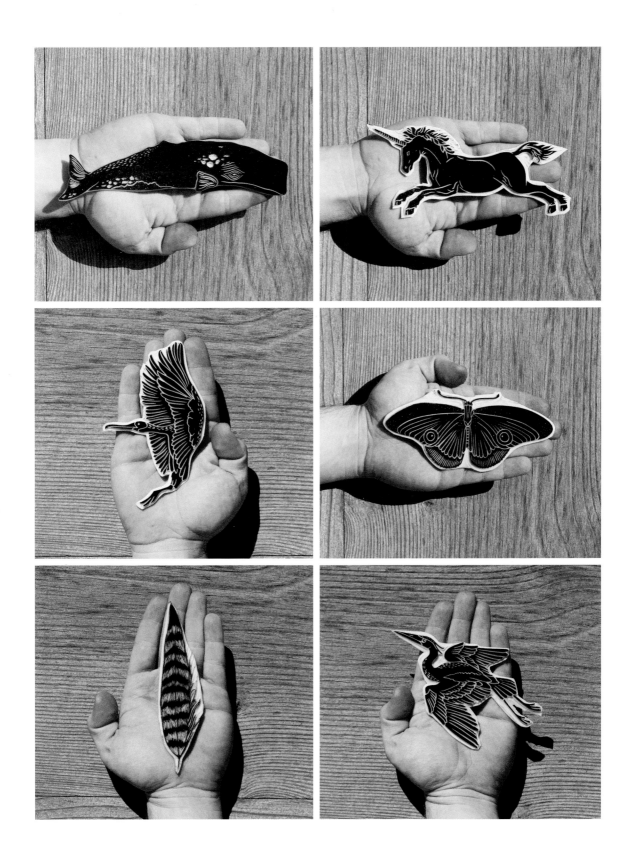

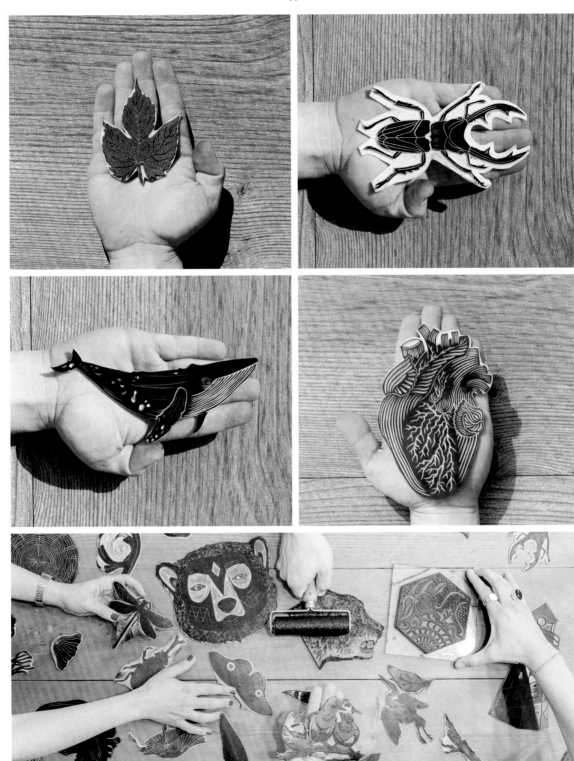

Judy Kameon & Erik Otsea

elysianlandscapes.com
plainair.com

Landscape designer Judy Kameon and photographer Erik Otsea, partners in all things, first started their professional collaboration in 1999 designing their line of outdoor furniture called Plain Air. Over the years, the two have teamed up on various projects, including the design of the iconic T logo for the NY Times T magazine and their first book Gardens Are For Living, published in 2014 by Rizzoli.

The creation of the T began with a freehand chromatic study painted in gouache. It was then translated into an arrangement of 130 plants in a wide range of colors, all which were later planted in the hillside demonstration garden at the couple's office.

This experience inspired a series of numerals from 1 through 10, which served as the chapter numbers for their book, each one unique and handmade, or homegrown, as was the case with number 5. Based in Los Angeles, Judy and Erik's work together is a reflection of their California roots and their shared belief that life is often best lived by spending time outside.

La diseñadora de exteriores Judy Kameron y el fotógrafo Erik Otsea, socios en todo, inicialmente empezaron su colaboración profesional en 1999, diseñando la línea de mobiliario de exterior llamada Plain Air. A lo largo de los años, los dos han formado equipo en varios proyectos incluyendo el diseño de el icónico logo T para el NY Times T magazine y su primer libro Los jardines son para vivir, publicado en 2014 por Rizzoli.

La creación de la T empezó con un estudio cromático a mano alzada pintado en gouache. Entonces se tradujo en un arreglo de 130 plantas en una amplia variedad de colores, los cuales fueron todos plantados después en el jardín de muestra en la ladera en la oficina de la pareja.

Esta experiencia inspiró una serie de numerales del 1 al 10, que sirvieron como los números de capítulo para su libro, cada uno único y hecho a mano, o cultivado en casa, como en el caso del número 5. Con sede en Los Ángeles, el trabajo de Judy y Erik juntos, es un reflejo de sus raíces californianas y de su creencia compartida de que la vida se vive mejor pasando tiempo fuera.

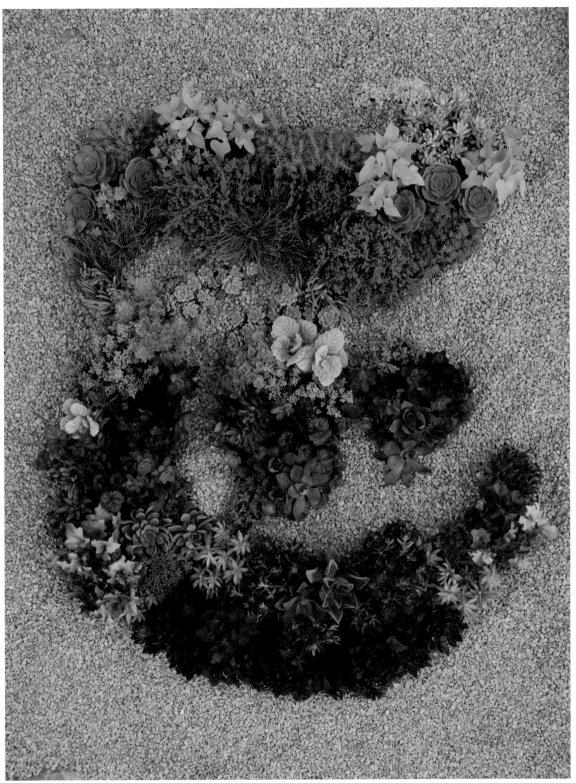

Judy Kameon & Erik Otsea

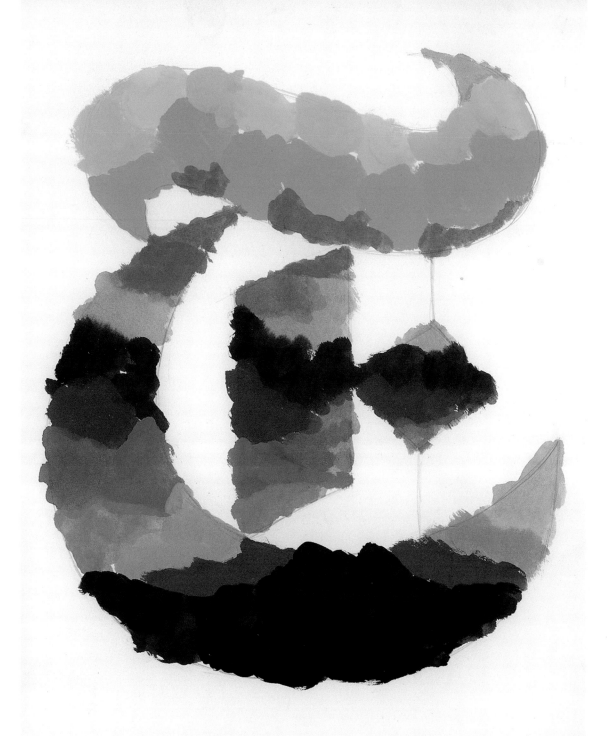

CHAMBERS

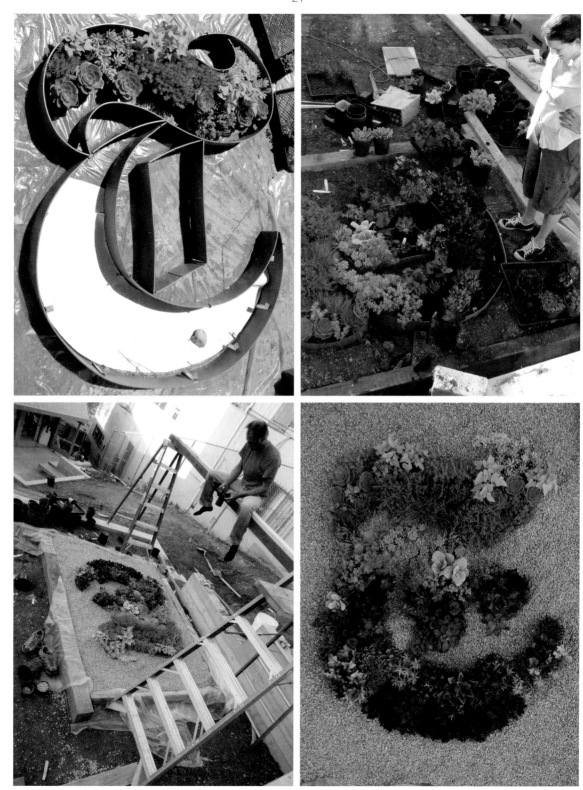

Judy Kameon & Erik Otsea

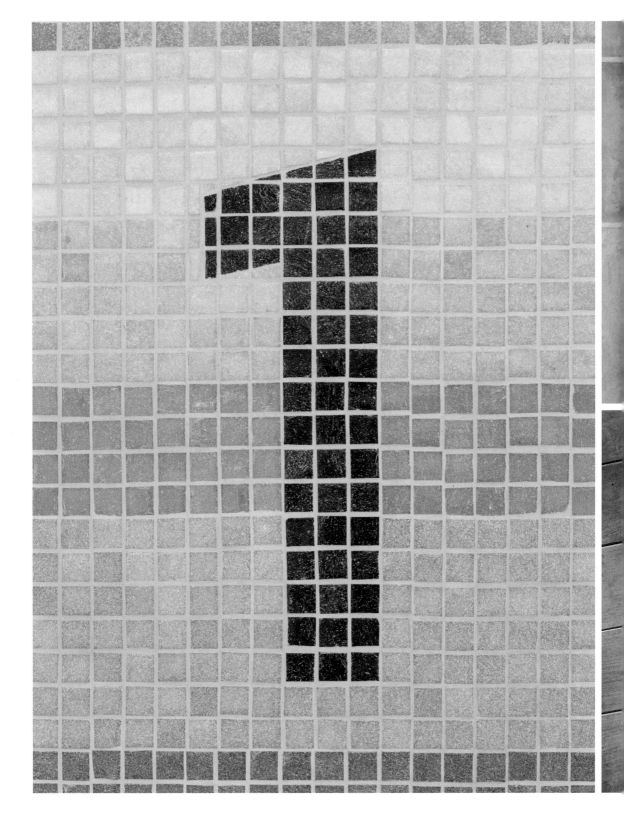

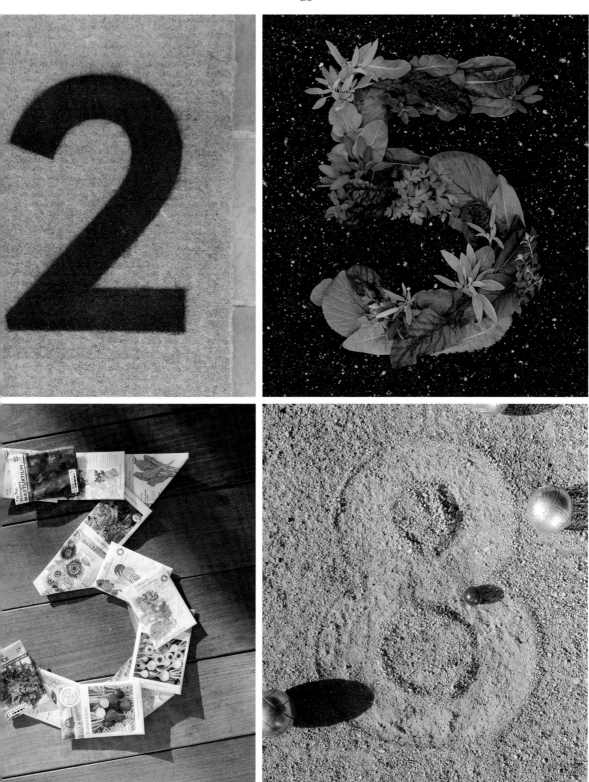

Judy Kameon & Erik Otsea

Jim Bachor

www.bachor.com

Chicago artist Jim Bachor adapts the mosaic, an art form that dates to at least the third millennium BC, and applies it to contemporary American life. From junk food to potholes to breakfast cereal, his vibrant work permanently locks into mortar unexpected concepts drawn from the present. Using the same materials, tools, and methods of the craftsmen of antiquity, he creates mosaics that speak of modern things, but in an ancient voice. By harnessing and exploiting the limitations of this indestructible technique, Bachor's work continually surprises the viewer, while challenging long-held notions of what a mosaic should be. Jim's work has been included in juried shows throughout the country and his Pothole art project attracted world-wide atttention this past summer. His first public art commission "thrive", a 700+ sqft mosaic, was recently installed at the Chicago Transit Authority's Thorndale Red Line station on the city's far northside. In 2014, Jim was also commissioned by Nike to install a giant (4' x 6') piece of pothole art in Niketown in downtown Chicago.

El artista de Chicago Jim Bachor adapta el mosaico, una forma de arte que data al menos del tercer milenio a.C. y lo aplica a la vida contemporánea americana. Desde comida basura a socavones, a cereales del desayuno, su trabajo vibrante sella en mortero permanentemente conceptos inesperados extraídos del presente. Usando los mismos materiales, herramientas, y métodos de los artesanos de la antigüedad, crea mosaicos que hablan de cosas modernas pero con una voz antigua. Empleando y explotando las limitaciones de esta técnica indestructible, el trabajo de Bachor sorprende continuamente al espectador, mientras reta las nociones largamente mantenidas sobre lo que debería ser un mosaico. El trabajo de Jim se ha incluido en muestras con jurado a lo largo del país y su proyecto artístico *Pothole* atrajo atención a nivel mundial este verano pasado. Su primer encargo artístico público "Thrive", un mosaico de 700+ pies cuadrados, fue recientemente instalado en la estación de la Red Line del Chicago Transit Authority's Thorndale. En 2014, Jim también recibió el encargo de Nike de instalar una pieza gigante (4' x 6') de arte socavón en Niketown en el centro de Chicago.

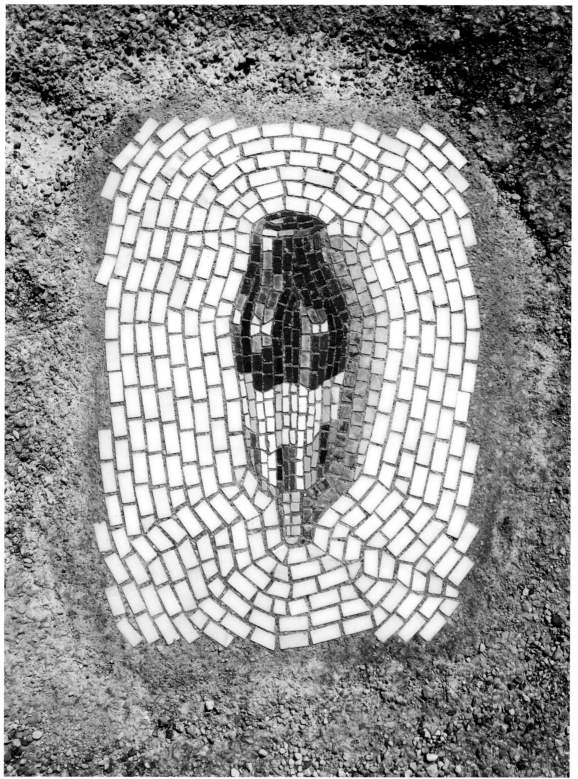

Bombpop, **Jim Bachor**

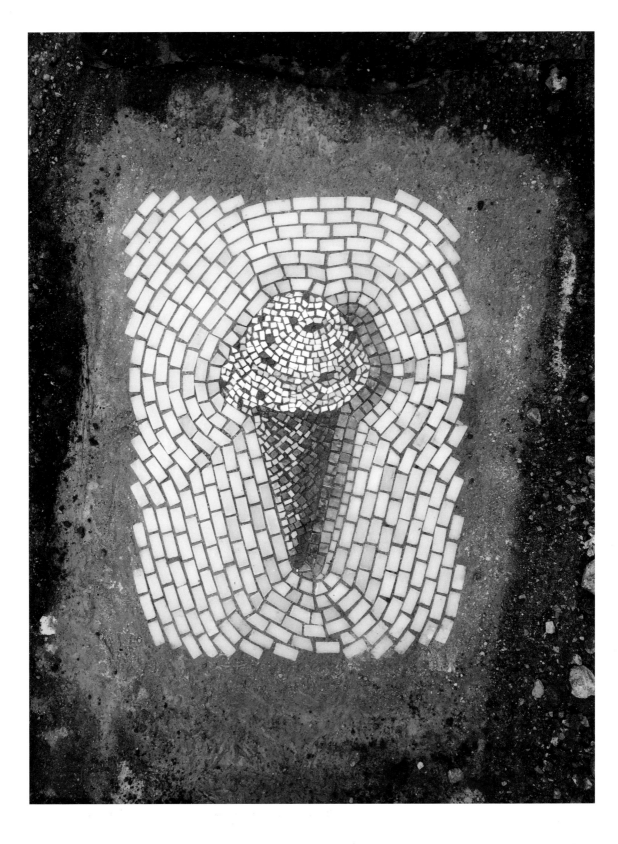

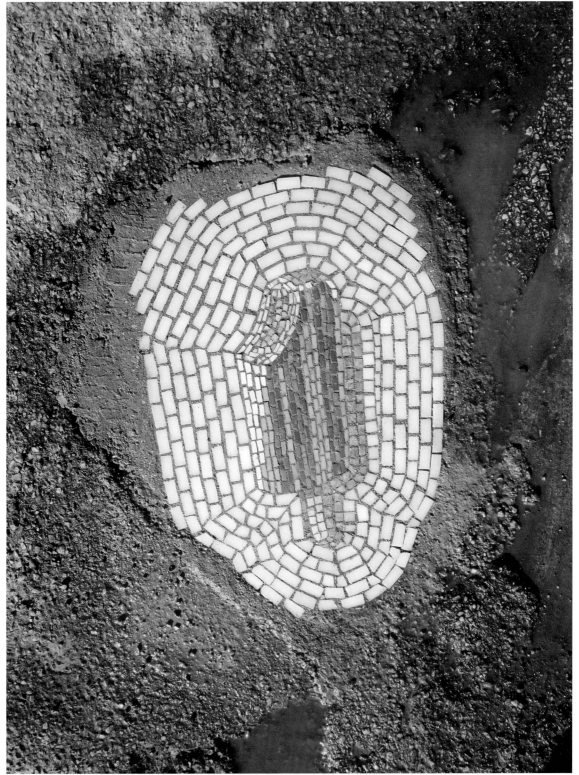

left: Single scoop ice cream cone, **Jim Bachor** / right: Creamsicle, **Jim Bachor**

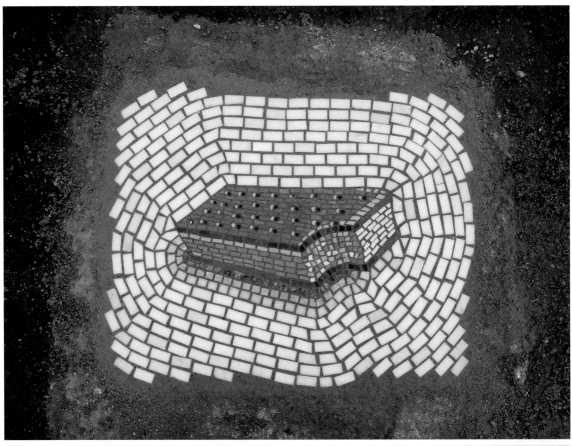
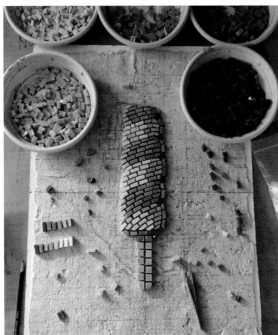
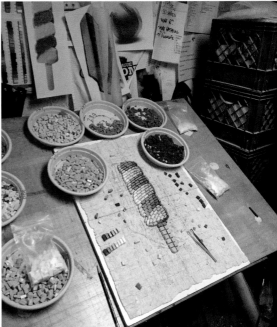

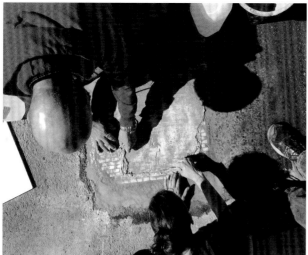

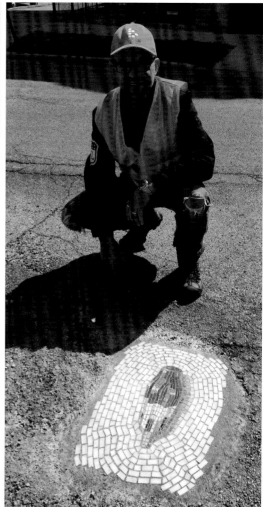

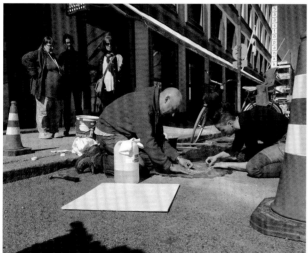

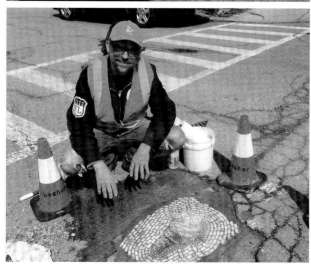

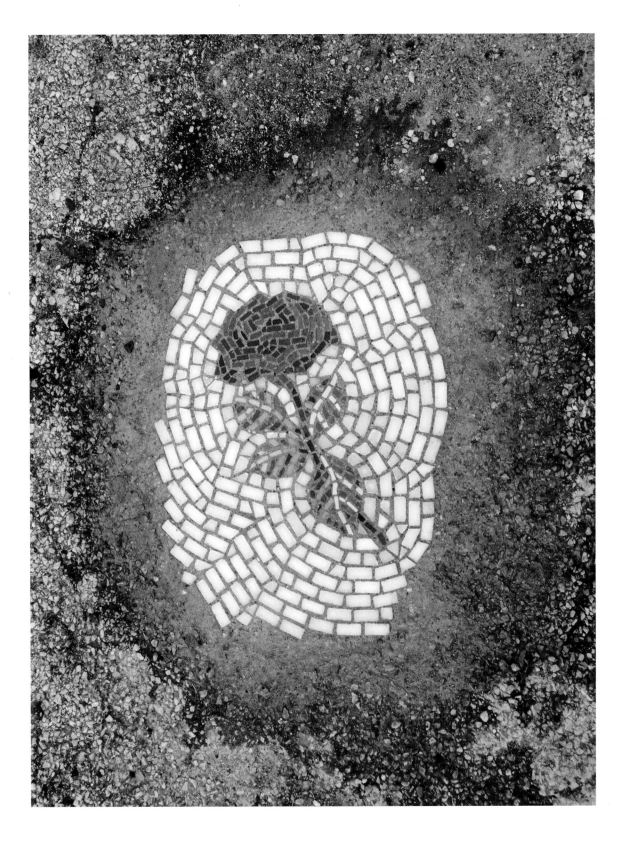

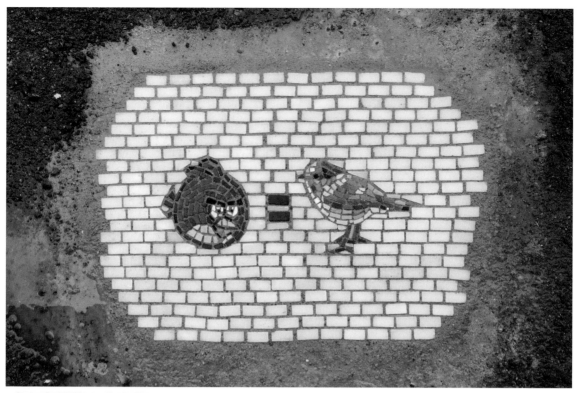

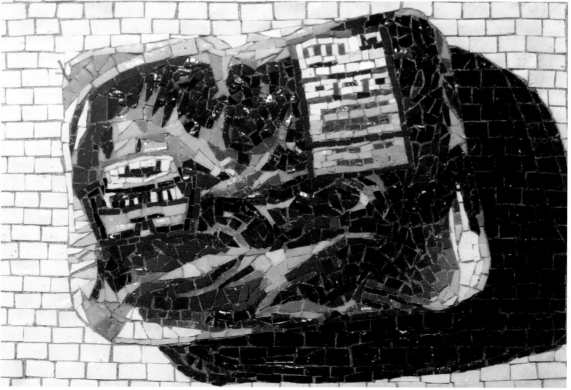

left: Rose pothole, **Jim Bachor** / right: top: Equal Birds, **Jim Bachor** bottom: Chuck Pot Roast, **Jim Bachor**

Wendy van Santen and Hans Bolleurs

www.wendyvansanten.com

Wendy and Hans are a Dutch creative couple. Their approach purposely blurs the lines between design & art, work & play.

They are photographers, illustrators, set designers, thinkers & makers working with everyday objects to tell stories.

From their studios in both Amsterdam and Rotterdam they work for clients all over the globe. It all started with a brocolli covered in colored sprinkles. An art project they started together. That was the starting point. Soon editorials in Amsterdam based newspaper Parool followed and snowballed from there to VPRO gids, glossies like LINDA and Red, Fast Company, Suddeutsche Zeitung and commercial clients like Tele2, IKEA, &Klevering and Sony Music.

Wendy and Hans love bold colors, minimalist compositions and aim to bring a smile to the mind. Their conceptual and colorful work can be found in both national and international newspapers, design books, magazines, music albums, social media and blogs.

Wendy y Hans son una pareja creativa holandesa. Su enfoque desdibuja intencionadamente las líneas entre diseño y arte, trabajo y juego.

Ellos son fotógrafos, ilustradores, diseñadores de sets, pensadores y hacedores, trabajando con objetos del día a día para contar historias.

Desde sus estudios en Ámsterdam y Rotterdam trabajan para clientes en todo el mundo. Todo empezó con brócoli cubierto de granitos de colores. Un proyecto artístico que empezaron juntos. Esto era el punto de inicio. Pronto, editoriales del periódico Parool con sede en Ámsterdam lo siguieron y crearon una bola de nieve de allí a lVPRO gids, revistas como LINDA y RED, Fast COmpany, Suddeutsche Zeitung y clientes comerciales como Tele2, IKEA, &Klevering y Sony Music.

A Wendy y a Hans les encantan los colores llamativos, las composiciones minimalistas e intentan traer una sonrisa a la mente. Su trabajo conceptual y colorido puede encontrarse en periódicos nacionales e internacionales, libros de diseño, revistas, álbumes de música, redes sociales y blogs.

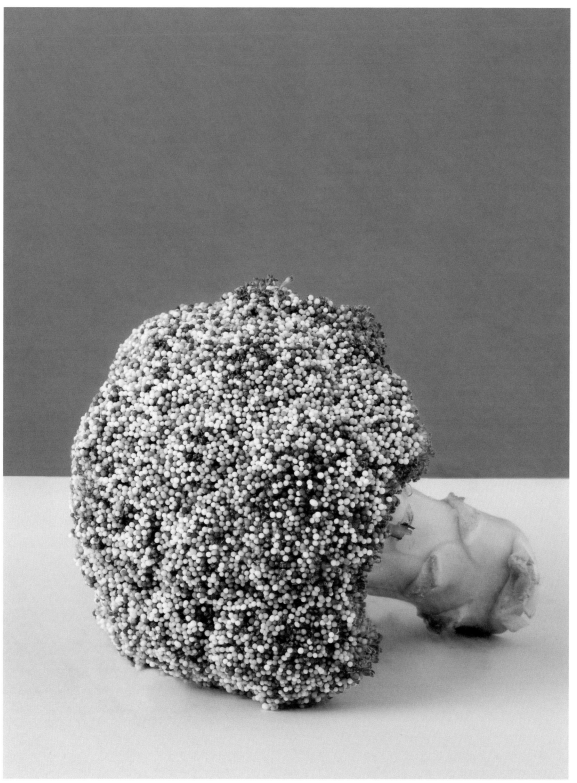

Sweet Veggies, **Wendy and Hans**

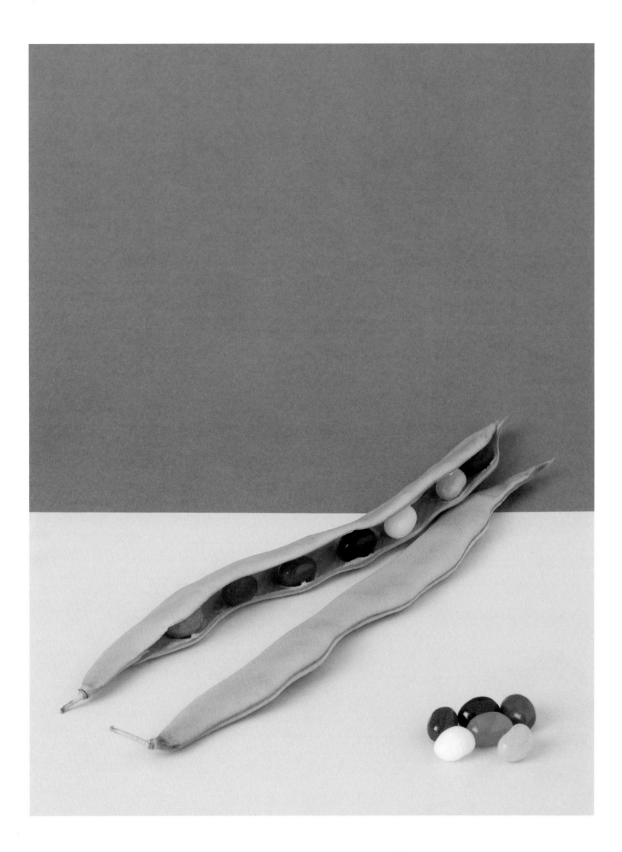

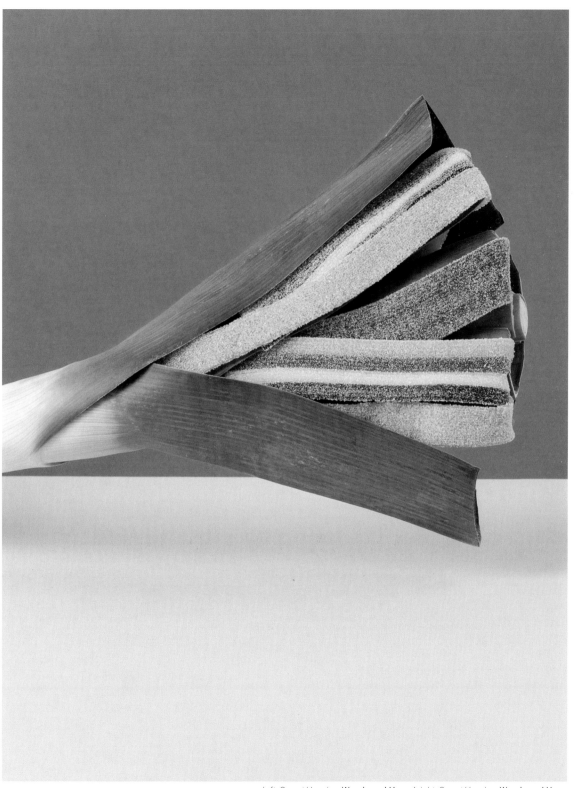

left: Sweet Veggies, **Wendy and Hans** / right: Sweet Veggies, **Wendy and Hans**

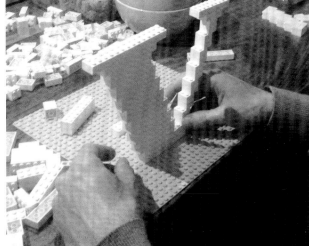

An editorial about the Lego movie
for Dutch Newspaper Volkskrant.
For this feature on the Lego
movie we created a directors
chair from Lego.
At first we tried to incorporate al
the figures from the movie but
together with the editor decided
that just hanging Lego Batman
from the ceiling would be
simpler and communicate more
clearly. The big letter 'V' in the
background we added to replace
the typography in the layout.

Un editorial sobre la película de
Lego para el periódico holandés
Newspaper Volkskrant.
Para este artículo sobre la
película de Lego creamos una
silla de director de Lego.
Inicialmente tratamos de
incorporar todas las figuras de
la película, pero junto con el
editor decidimos que solamente
colgando un Batman de Lego
del techo sería más simple y
comunicaría con más claridad.
La gran letra 'V' la añadimos
al fondo para remplazar la
tipografía del diseño.

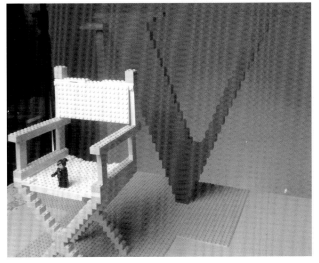

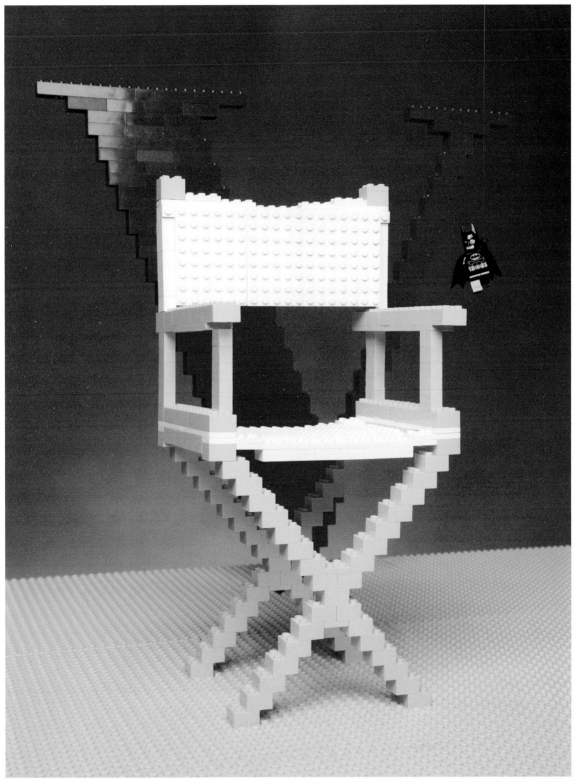

Lego Movie, **Wendy and Hans**

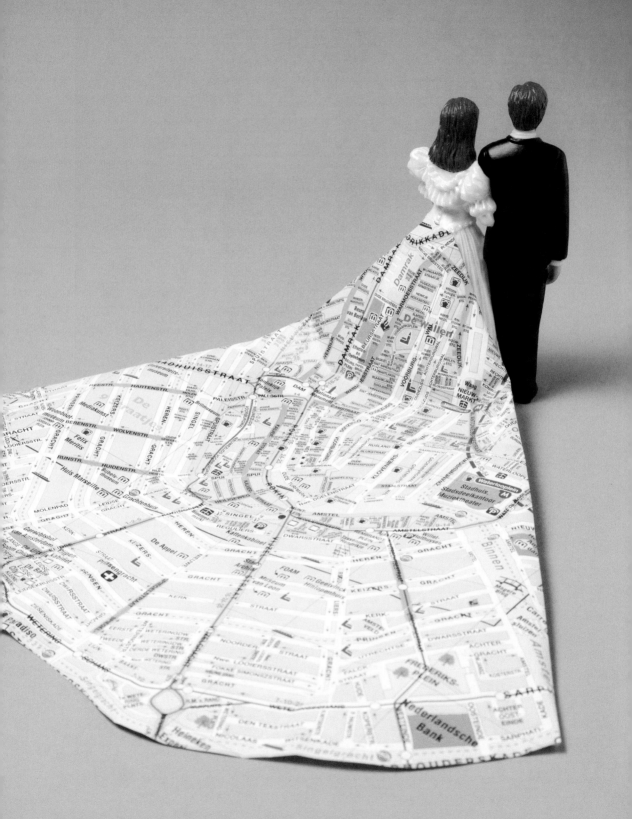

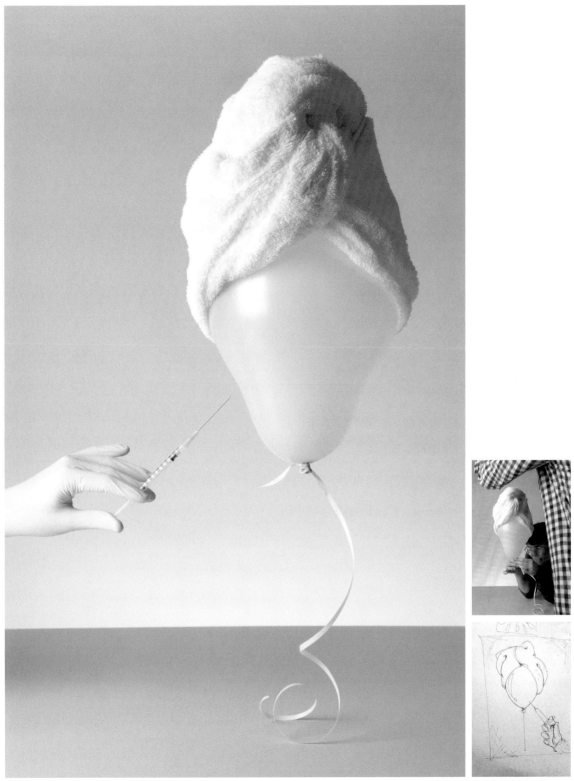

left: Wedding locations, **Wendy and Hans** / right: Dangerous Botox, **Wendy and Hans** in collaboration with Bibi Silver Funcke

Debbie Smyth

www.debbie-smyth.com

Debbie Smyth is textile artist most identifiable by her statement thread drawings; these playful yet sophisticated contemporary artworks are created by stretching a network of threads between accurately plotted pins. Her work beautifully blurs the boundaries between fine art drawings and textile art, flat and 3D work, illustration and embroidery, literally lifting the drawn line off the page in a series of "pin and thread" drawings.

Debbie plays with scale well; creating both gallery installations and works for domestic interiors. Her unique style lends itself to suit corporate environments, public spaces, window display, set design, graphic design and illustration. By collaborating with interior designers, architects and other creative practitioners, Debbie pushes the expected scope of her work even further. "I feel as if I am taking thread out of its comfort zone, presenting it on monumental scale and creating an eye-catching, and in some case jaw dropping effect"

Debbie has worked with companies both nationally and internationally including Adidas, Ellesse, The New York Times, Mercedes Benz, The Canadian Red Cross, Sony, Hamburg Philharmonic Orchestra, Hermes and The Dorchester Hotel Group.

Debbie Smyth es una artista del textil más identificable por sus declarativos dibujos en hilo; estas juguetonas y aún así contemporáneas obras de arte se crean estirando una red de hilos entre alfileres precisamente colocados. Su trabajo difumina con gran belleza los límites entre las bellas artes y el arte textil, plano y trabajo en 3D, ilustración y bordado, levantando literalmente la línea dibujada fuera de la página en una serie de dibujos de "alfiler e hilo".

Debbie juega hábilmente con la escala; creando ambas, instalaciones de galería y trabajos para interiores domésticos. Su estilo único se presta a encajar con ambientes corporativos, espacios públicos, escaparates, diseños de set, diseño gráfico e ilustración. Colaborando con diseñadores de interior, arquitectos y otros profesionales creativos, Debbie lleva la expectativa del alcance de su obra aún más allá. "Siento que estoy llevando el hilo más allá de su zona de confort, presentándolo en una escala monumental y creando un atractivo, y en algún caso impresionante efecto".

Debbie ha trabajado con empresas tanto nacionalmente como internacionalmente, incluyendo Adidas, Ellesse, The New York Times, Mercedes Benz, The Canadian Red Cross, Sony, Hamburg Philharmonic Orchestra, Hermes y The Dorchester Hotel Group.

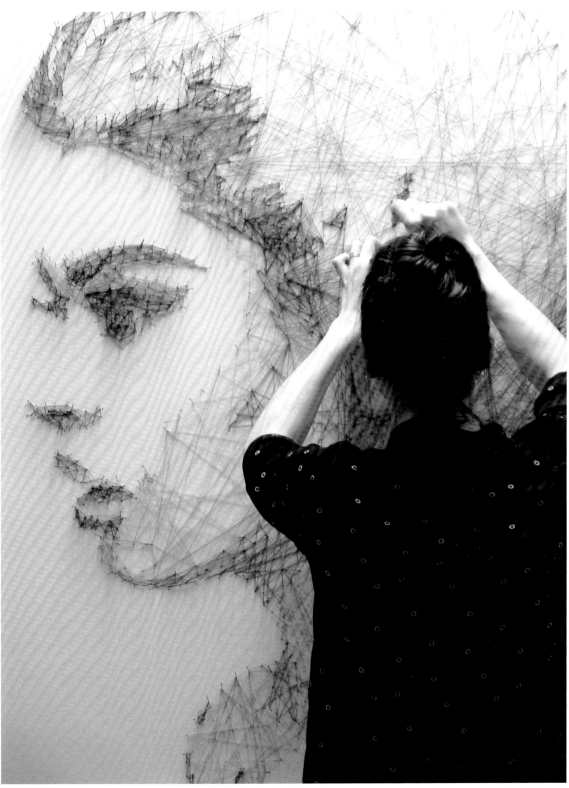
Debbie Smyth

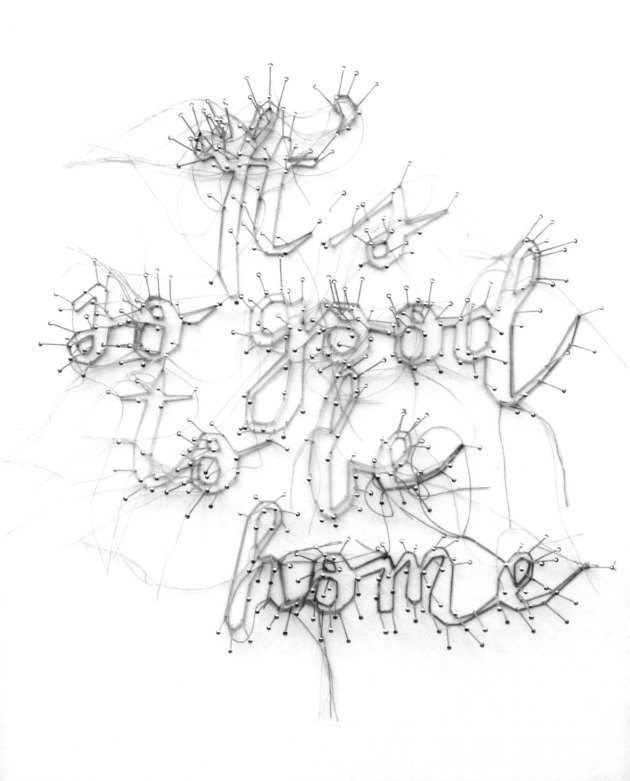

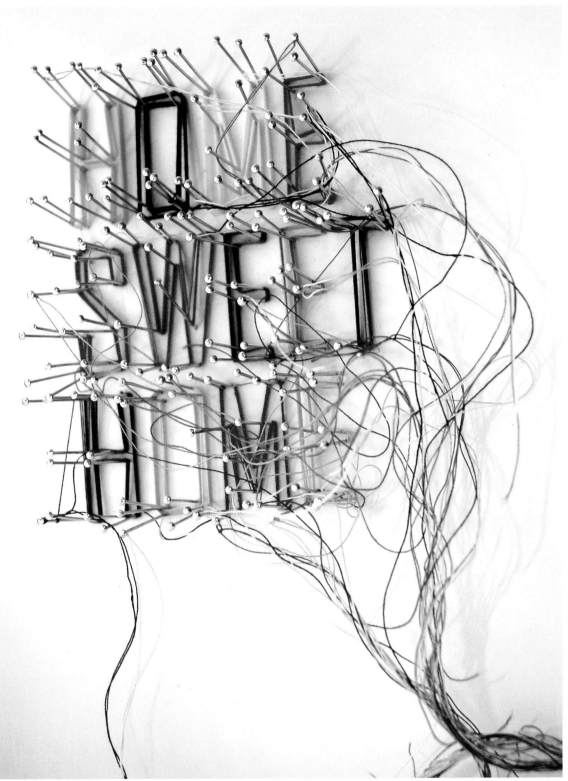

left: It is so good to be home, **Debbie Smyth** / right: Home Sweet Home (25x25cm), **Debbie Smyth**

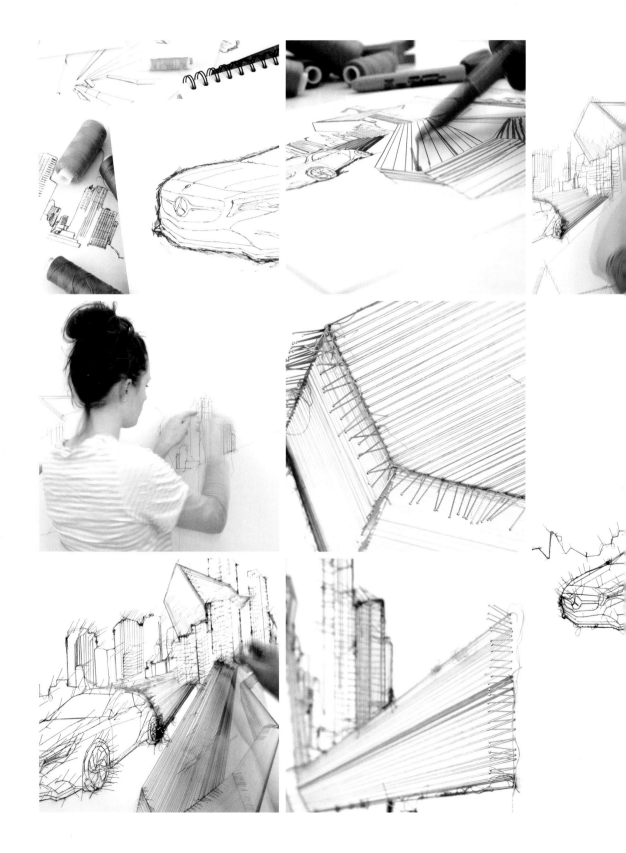

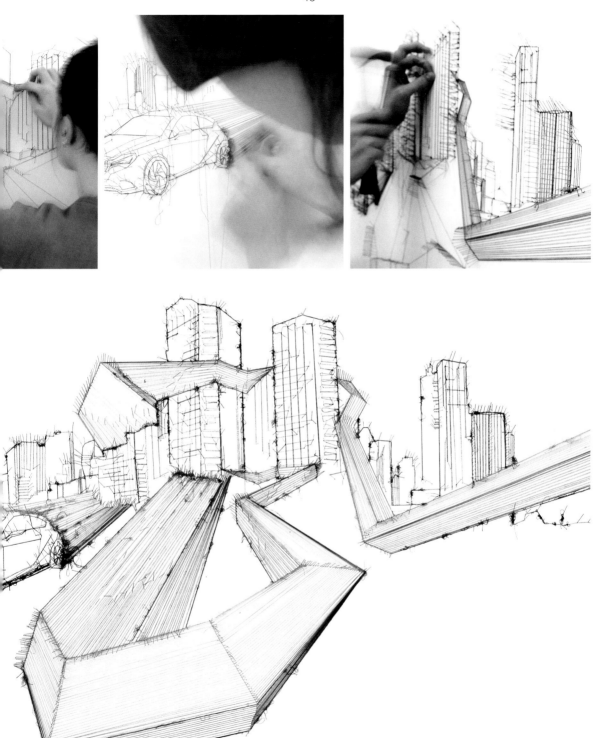

Mb! by Mercedes-Benz, **Debbie Smyth**

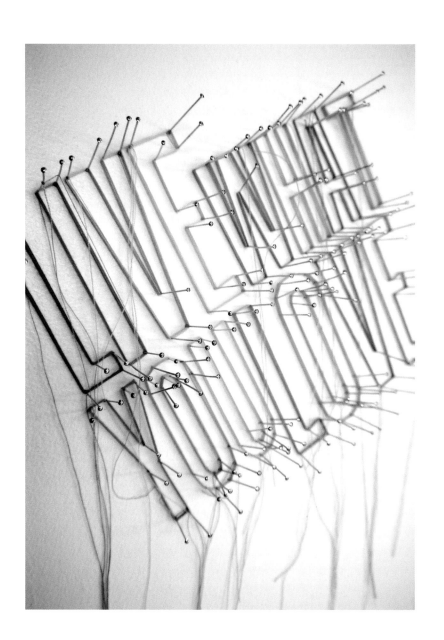

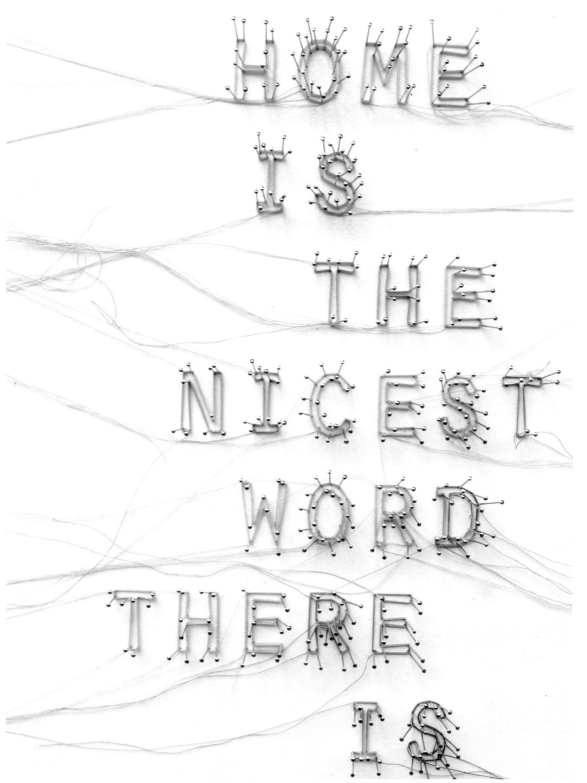

left: Live what you love (20x30cm), **Debbie Smyth** / right: Home is the nicest word there is, **Debbie Smyth**

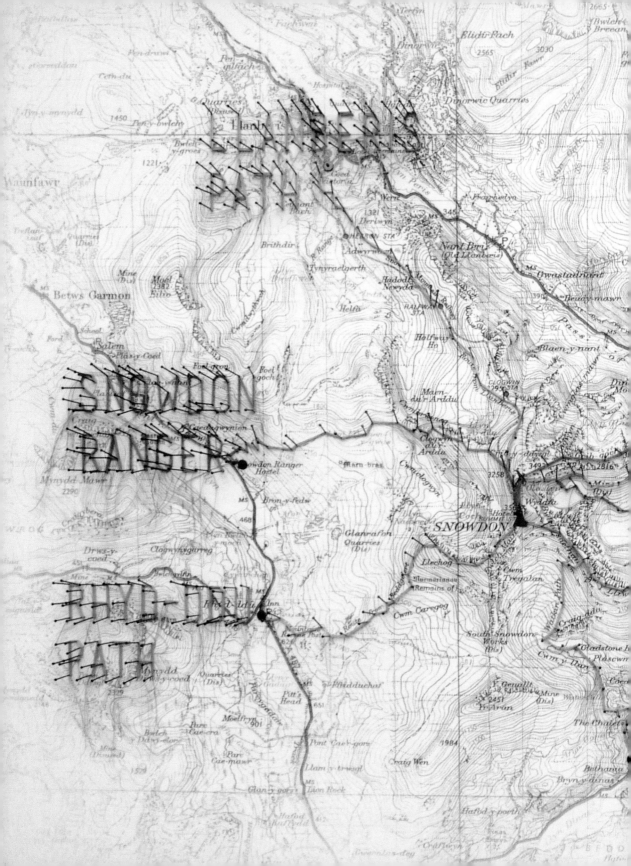

CRIB GOCH

PYG TRACK

MINER'S TRACK

LLIWEDD

... PATH

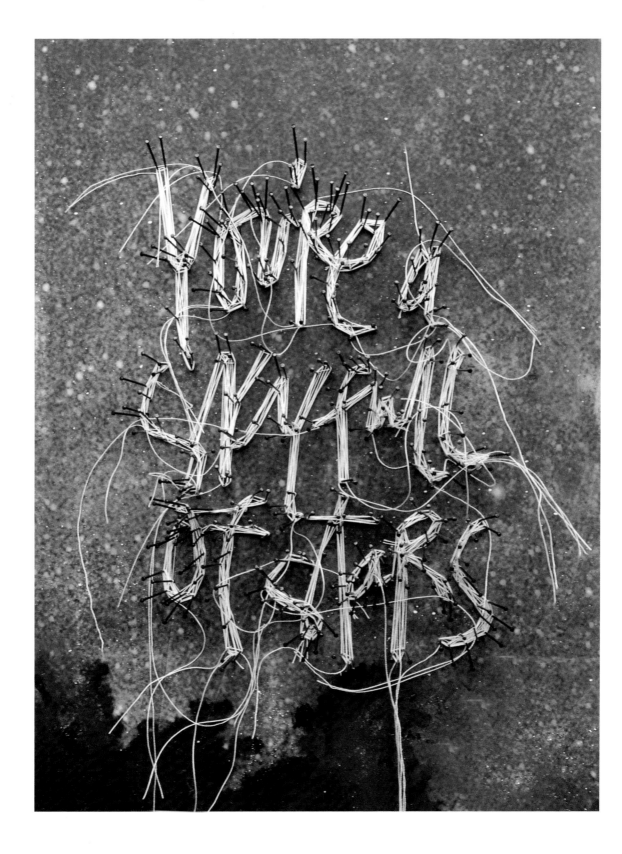

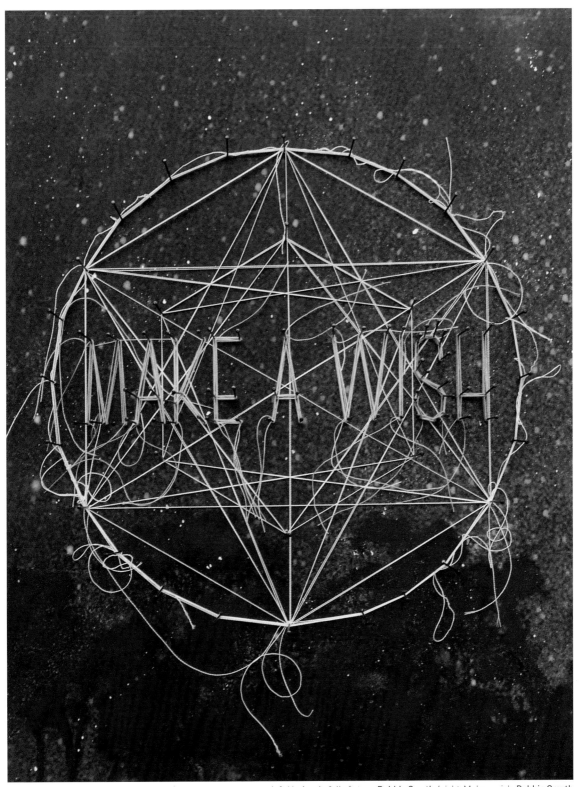

left: You're skyfull of stars, **Debbie Smyth** / right: Make a wish, **Debbie Smyth**

Gemma O'Brien

www.gemmaobrien.com

Gemma O'Brien is an Australian artist specialising in lettering, illustration and typography. After studying design at the College of Fine Arts in Sydney, Gemma worked as an art director at Animal Logic, Fuel VFX and Toby and Pete before deciding to fly solo as a commercial illustrator in 2012. She is currently represented by the Jacky Winter Group and splits her time between advertising commissions, gallery shows, speaking engagements and hosting hand-lettering workshops around the world. Her typography work takes on a variety of forms, from calligraphic brushwork, illustrated letterforms and digital type to large scale hand-painted murals. Her clients include Adobe, Volcom, Heineken, Kirin Cider, QANTAS, Heinz, Smirnoff and The New York Times. A number of her projects have been recognised by the New York The Type Directors Club with Awards of Typographic Excellence. In her spare time she travels and draws puke puns on barf bags for the Spew Bag Challenge.

Gemma O'Brien es una artista australiana especializada en caligrafía, ilustración y tipografía. Después de estudiar diseño en la facultad de Bellas artes de Sídney, Gemma trabajó como directora artística en Animal Logic, Fuel VFX y Toby and Pete antes de decidirse a volar en solitario como ilustradora comercial en 2012. Actualmente está representada por el Grupo Jacky Winter y divide su tiempo entre encargos publicitarios, exposiciones en galerías, charlas y organizando talleres de caligrafía a lo largo del mundo. Su trabajo en tipografía toma una variedad de formas, desde pincel caligráfico, formas de letras ilustradas y tipografía digital hasta murales de gran escala pintados a mano. Sus clientes incluyen Adobe, Volcom, Heineken, Kirin Cider, QANTAS, Heinz, Smirnoff y The New York Times. Un número de sus proyectos han sido reconocidos por el New York The Type Directors Club con premios a la Excelencia Tipográfica. En su tiempo libre trabaja y dibuja juegos de palabras en bolsas para el Spew Bag Challenge.

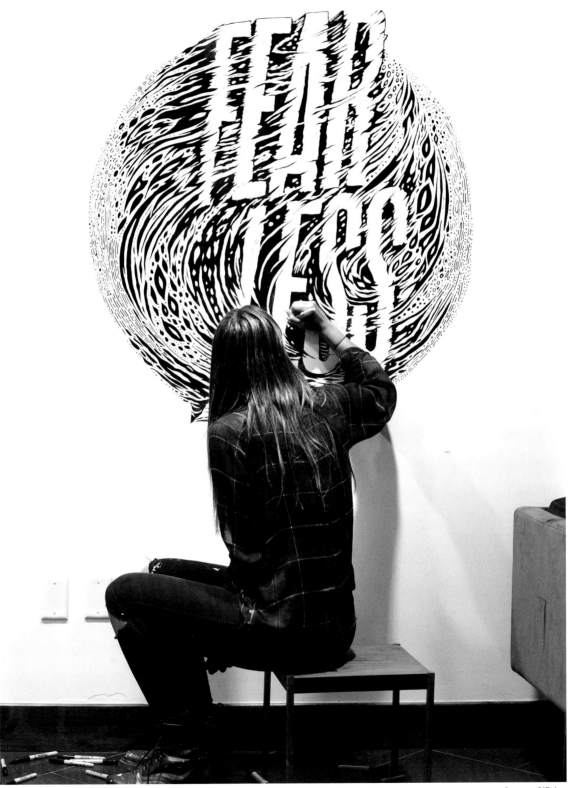

Gemma O'Brien

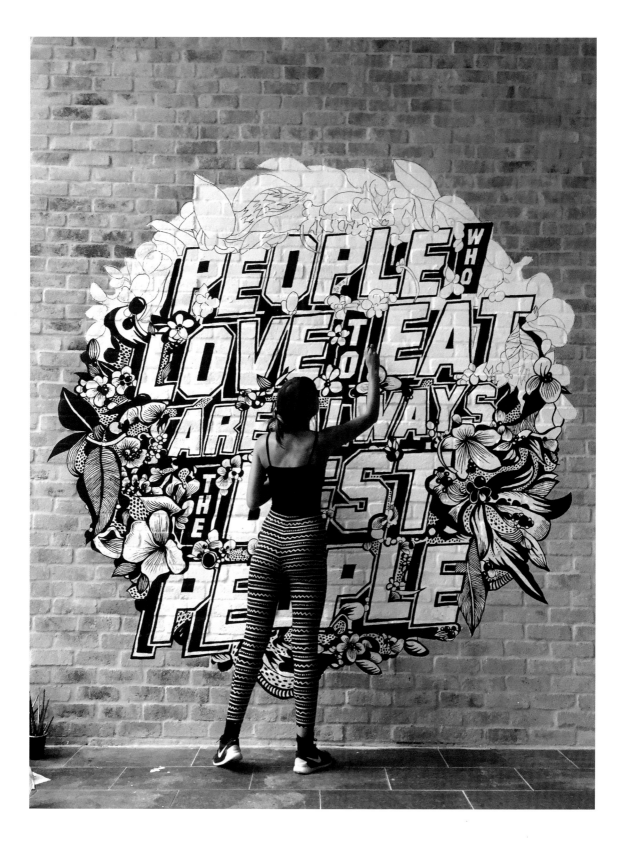

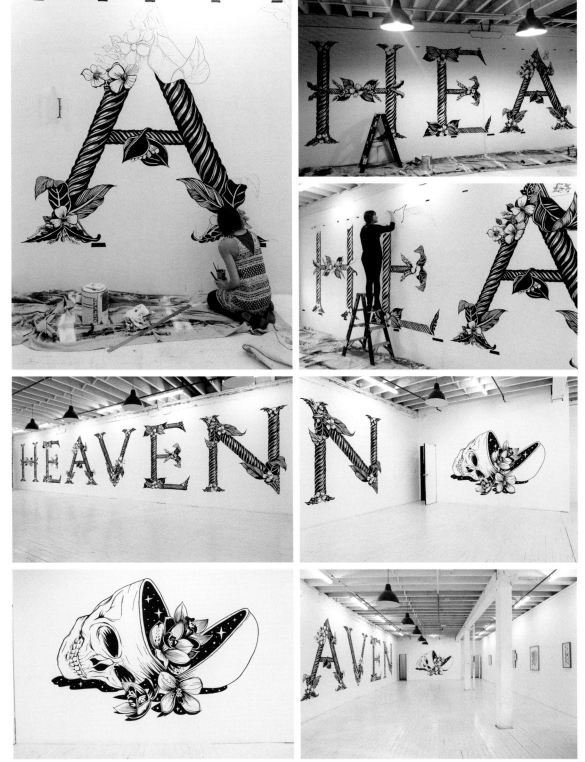

Gemma O'Brien

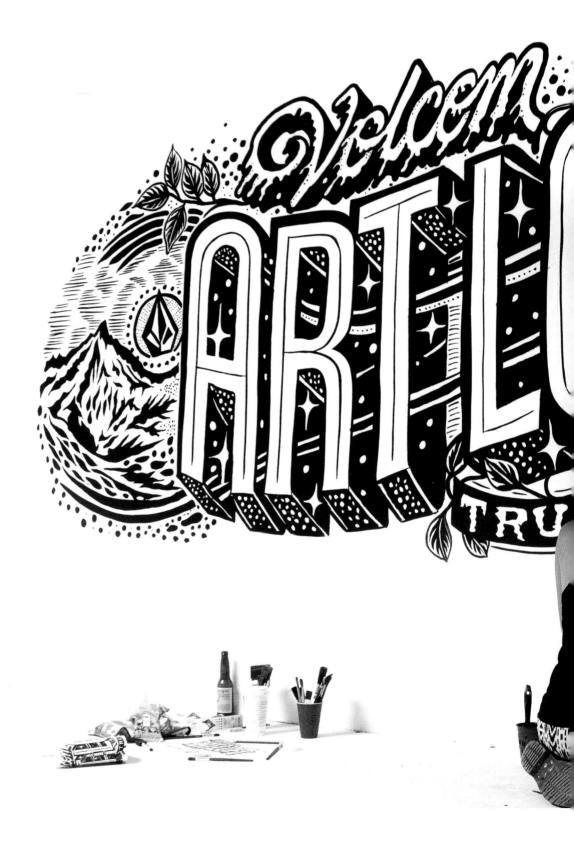

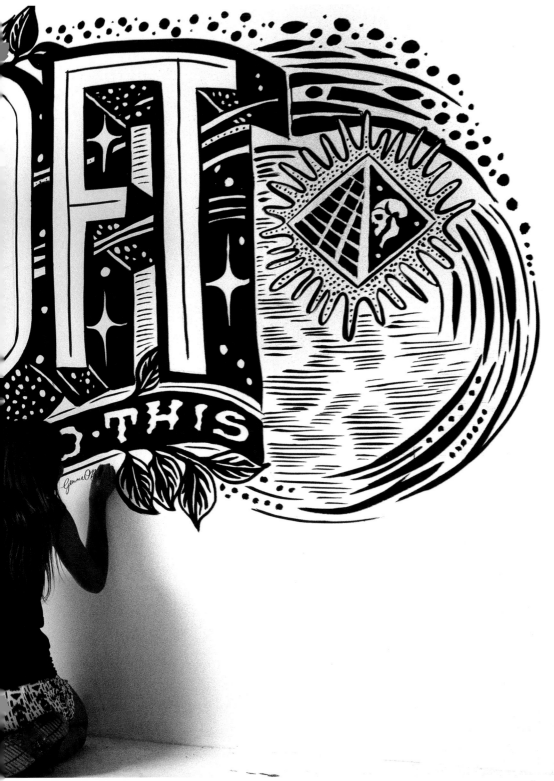

Gemma O'Brien

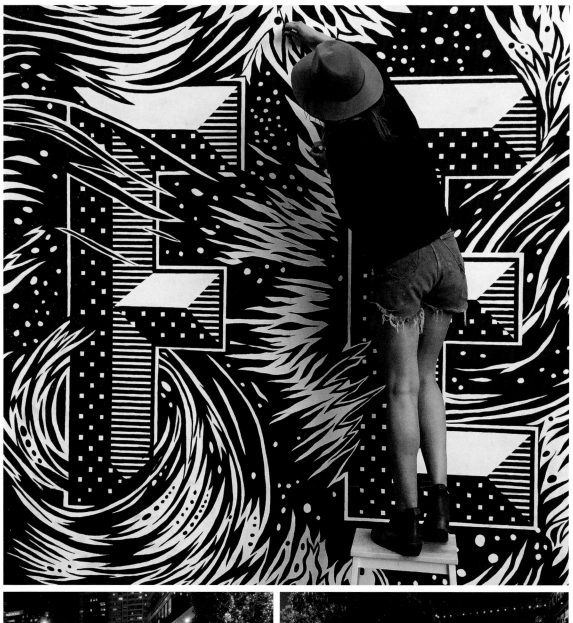

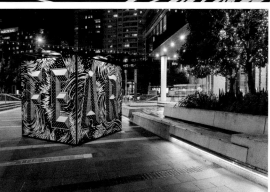

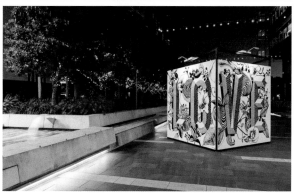

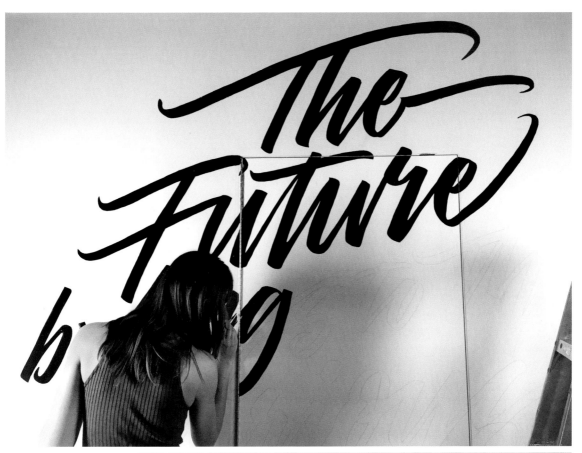

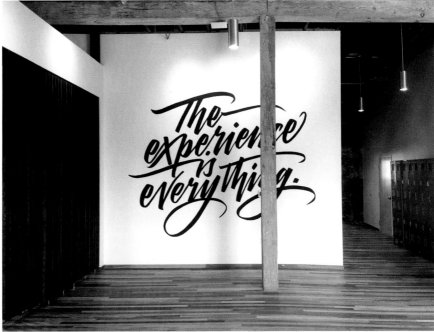

Gemma O'Brien

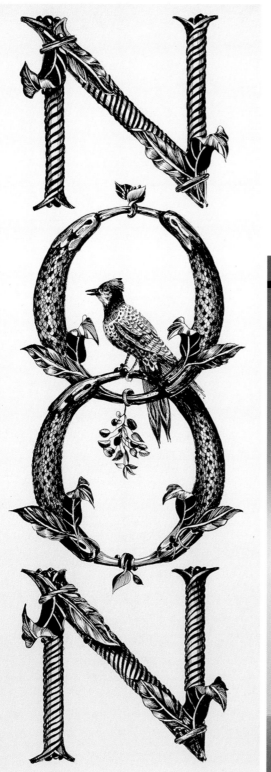

The Dictionary of Dangerous Ideas
Mike Walsh

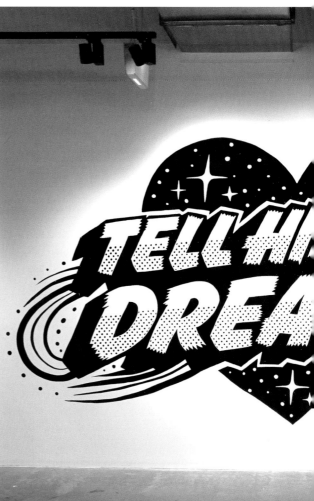

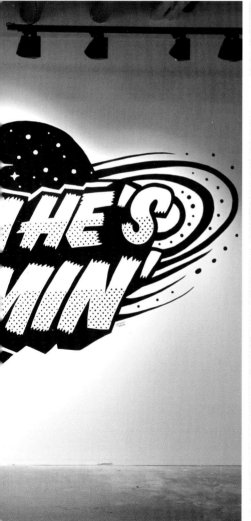

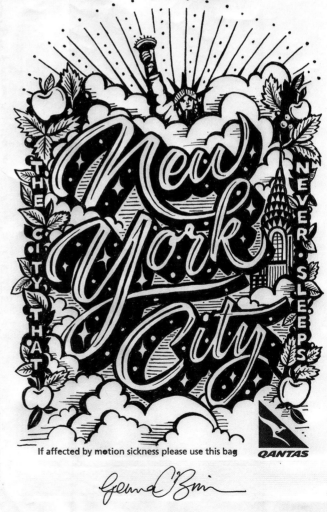

Gemma O'Brien

Alicia Rosello

www.aliciarosello.com
www.duduadudua.com

Her name is Alicia and she lives in Barcelona. In 2006 she created Duduá, a craft shop and independent art gallery. Her goal was to introduce different craft techniques to her generation, that might have thought that crafts were only for grannies or something old-fashioned and boring. She started organizing workshops, promoting artists, creating her own brand and experimenting with new materials, of different shapes and sizes. She recovered older techniques that had been forgotten about and presented them in a new and different way. In 2010 she created the "Crochet Guerrilla", a group of people that do crafts in the street. It is a way of converting a traditional craft into something social, fun and public!

Nowadays Alicia's work has evolved into a wider creative field, working for agencies, designers and brands.

Su nombre es Alicia y vive en Barcelona, En 2006 creó Duduá, una tienda de artesanía y galería de arte independiente. Su objetivo era introducir a su generación en distintas técnicas artesanales, gente que podría haber pensado que la artesanía era solo para abuelas o algo anticuado y aburrido. Empezó organizando talleres, promocionando a otros artistas, creando su propia marca y experimentando con nuevos materiales de diferentes formas y tamaños. Recuperó antiguas técnicas que habían sido olvidadas y las presentó de una forma nueva y diferente. En 2010 creó la "Guerrilla del Crochet", un grupo de gente que hace artesanía en las calles ¡Es una forma de conseguir convertir la artesanía tradicional en algo social, divertido y público!

Hoy en día, el trabajo de Alicia ha evolucionado a un campo creativo más amplio, trabajando para agencias, diseñadores y marcas.

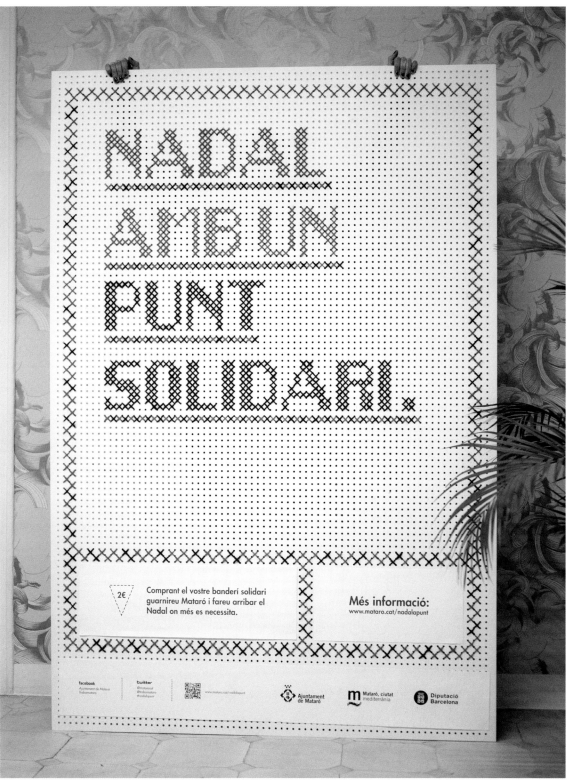

Campaña Ayuntamiento Mataró punto de cruz XL. Realizado por Núria Brunet y **Alicia Rosello**

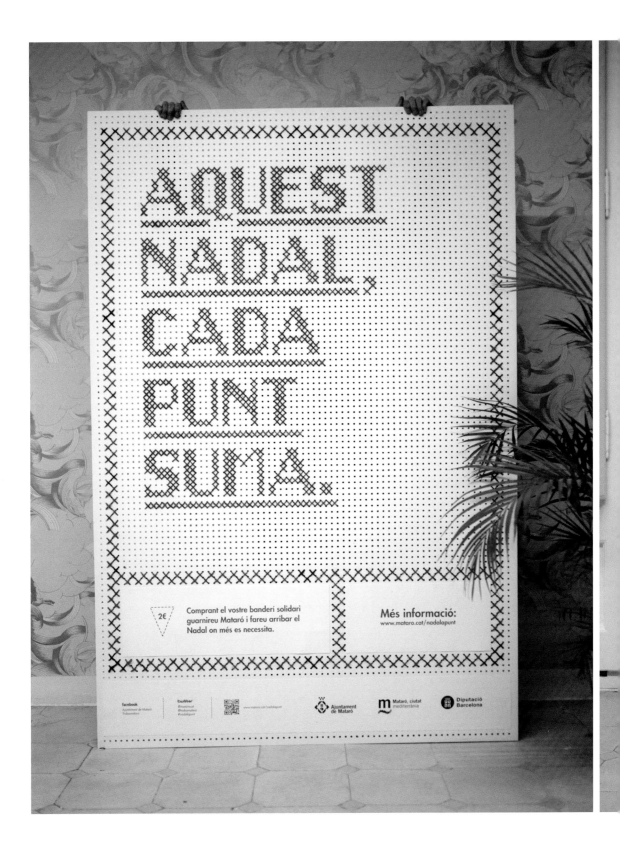

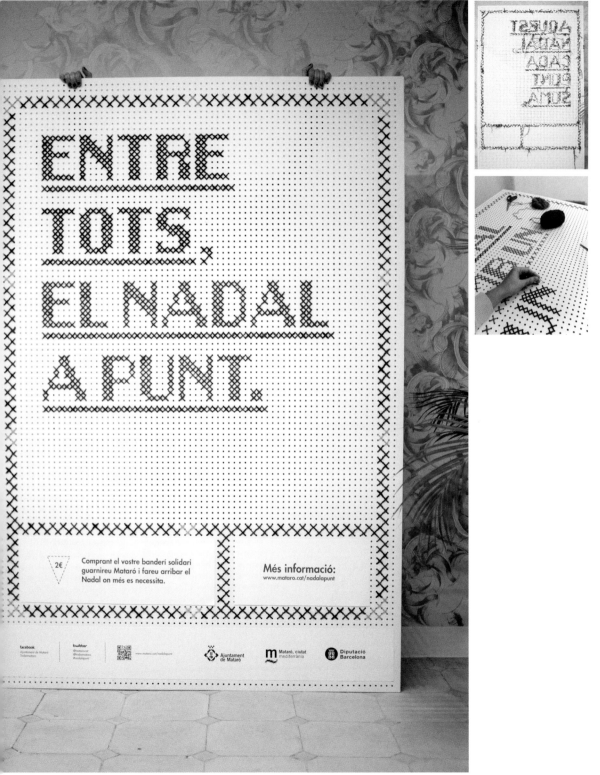

Campaña Ayuntamiento Mataró punto de cruz XL. Realizado por Núria Brunet y **Alicia Rosello**

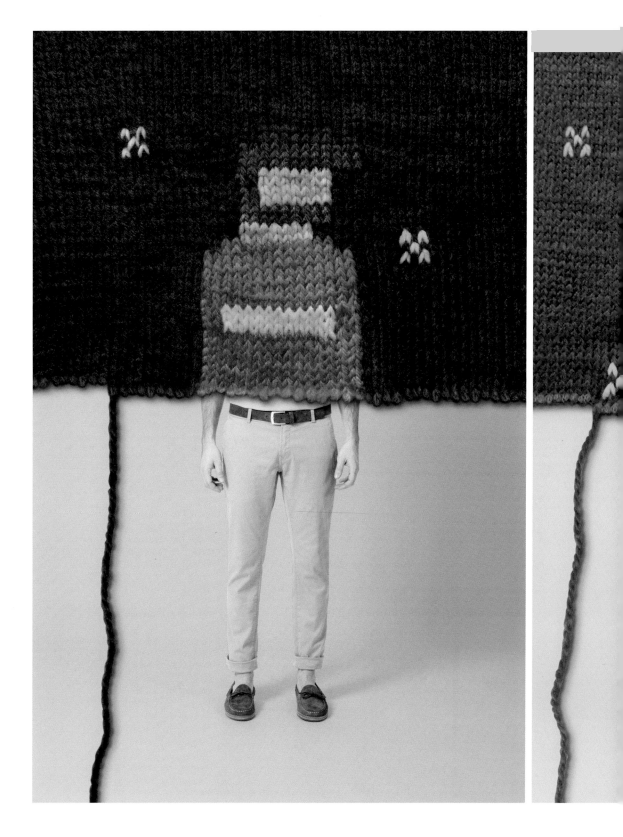

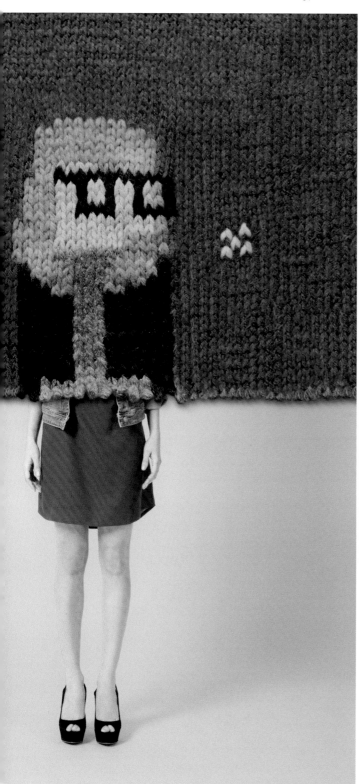

Campaña Illa Diagonal 2012, en tricot Proyecto con Las ColeccionistasTricot realizado por Clàudia Font y **Alicia Rosello**

Danielle Evans

marmaladebleue.com
foodtypography.com
marmaladebleue.com/blog

Danielle is lettering artist and designer based out of Columbus, Ohio. She has pioneered food typography, food styling with a typographer's touch, and continues to blaze trails with her inventive style of art direction and design. Her work has been hailed as original, thoughtful, and delicious imagery. She has worked with fine clients such as Target, Aria, TAZO, Bath & Body Works, Cadillac, Purina, The Guardian, The Washington Post and Kellogg.

Danielle es una artista de la caligrafía y el diseño con sede en Columbus, Ohio. Ha sido una pionera en la tipografía culinaria, estilismo culinario con toque de tipógrafo, y continúa desplegando caminos con su inventivo estilo de dirección artística y de diseño. Su trabajo ha sido aclamado como original, reflexivo y con una imaginería deliciosa. Ha trabajado con clientes distinguidos como Target, Aria, TAZO, Bath & Body Works, Cadillac, Purina, The Guardian, The Washington Post y Kellogg.

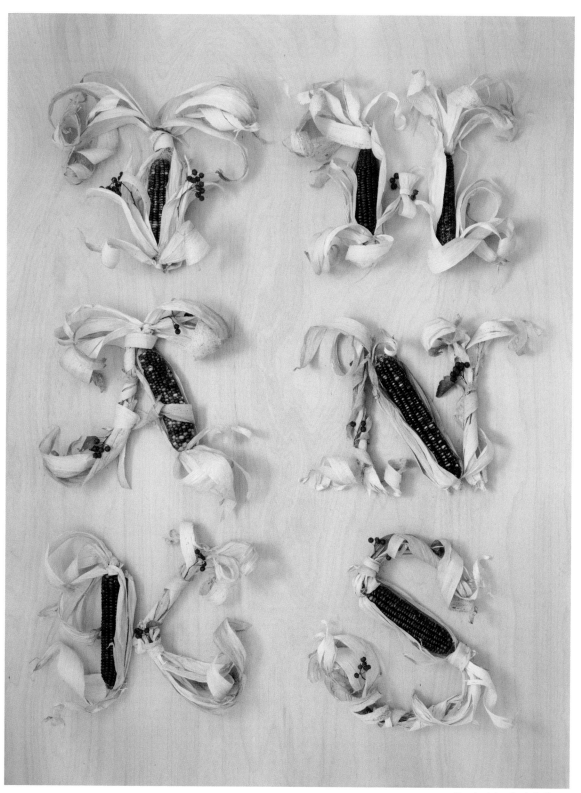

Thanksgiving, **Danielle Evans**

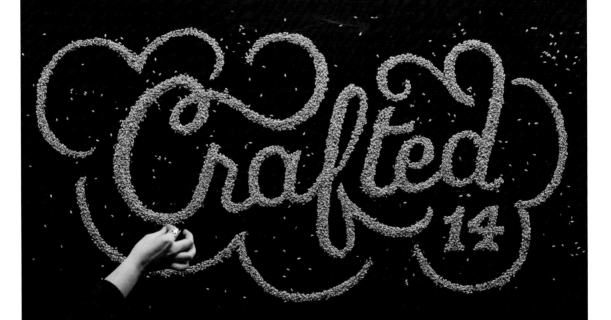

**FIRST WE MAKE.
THEN WE PARTAKE.**

A·A·F

ADDYS® 2013-2014
Don't be left out! Commit. Submit. Then feast
and imbibe with the city's great makers.

For more details visit: **cincinnatiaddys.com**

ENTRY DEADLINE
6 PM Friday, December 6, 2013
Early Discount Deadline: Wednesday, November 27
Enter Online: cincinnatiaddys.com
Entry Drop Off: Graydon Head & Ritchey
Northern Kentucky, at the Chamber Center
2400 Chamber Center Drive, Suite 300
Ft. Mitchell, KY 41017

EVENT
6 PM Saturday, February 22, 2014
Moerlein Tap Room
1621 Moore St, Over-the-Rhine

Valet Parking Available

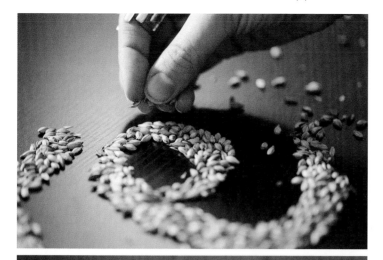

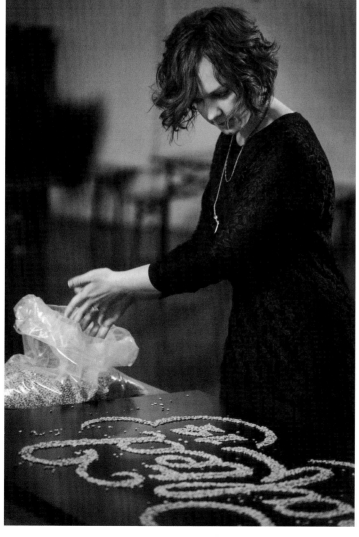

Crafted, Danielle Evans

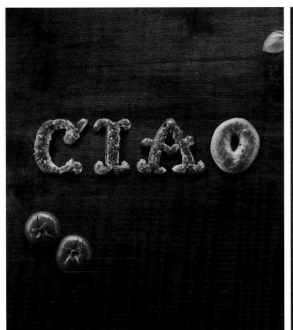

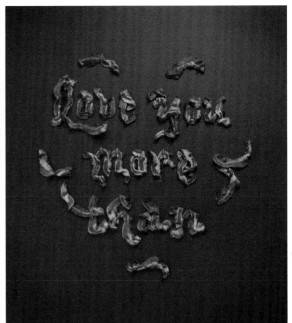

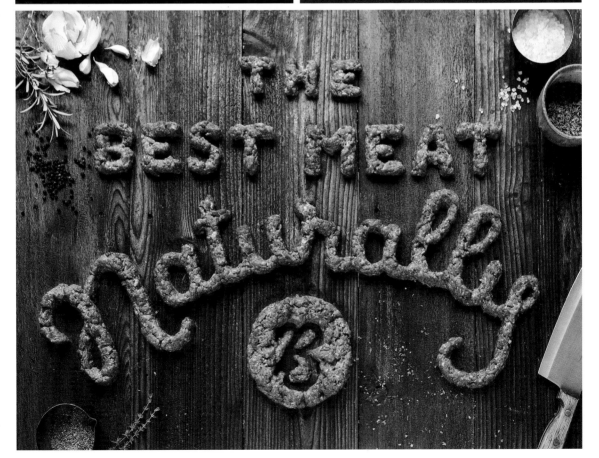

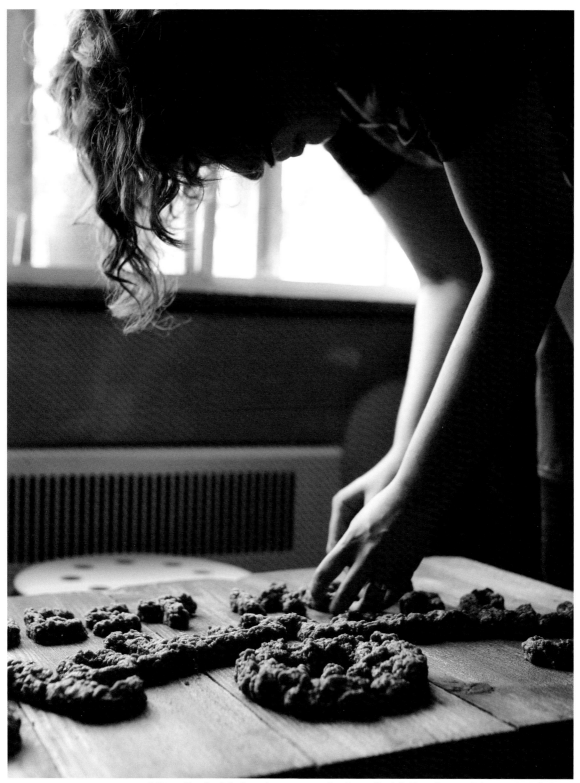

left: top, Ciao, **Danielle Evans** Love you more than bacon, **Danielle Evans bottom,** Belcampo, **Danielle Evans**

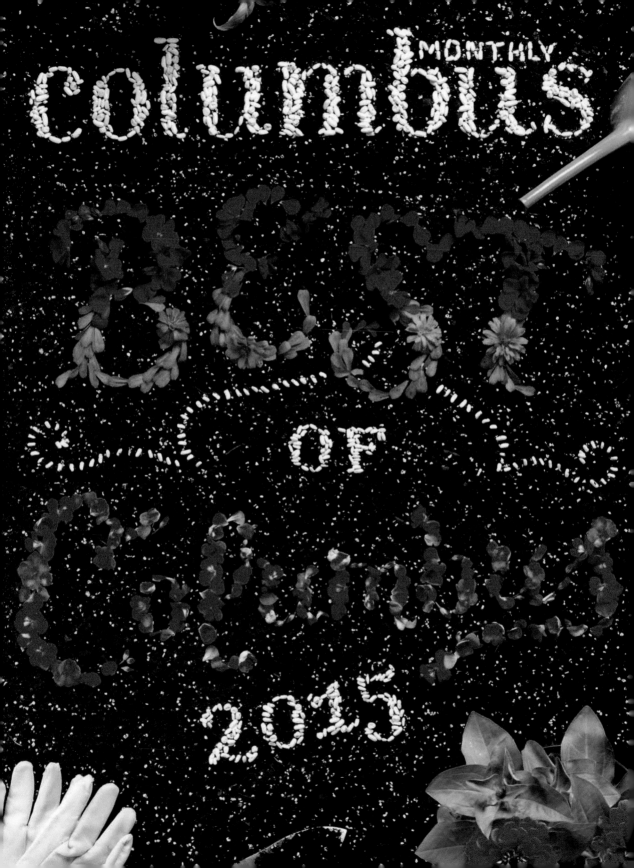

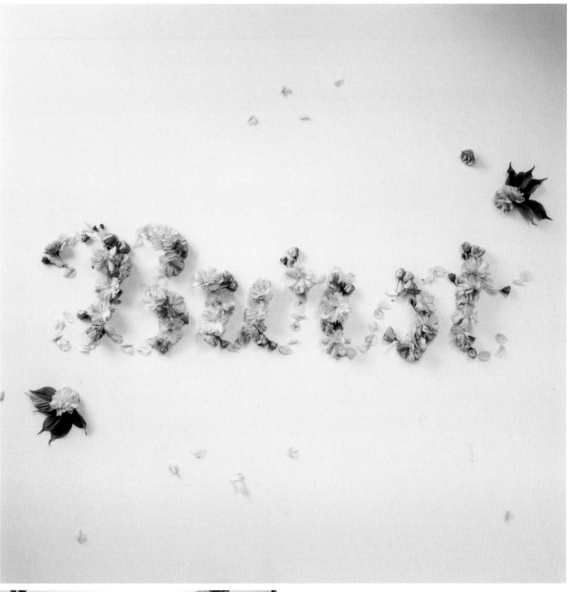

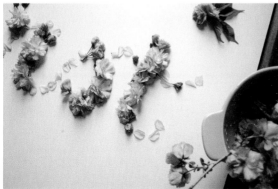

left: Best of Columbus, **Danielle Evans** / right: Burst into Bloom, **Danielle Evans**

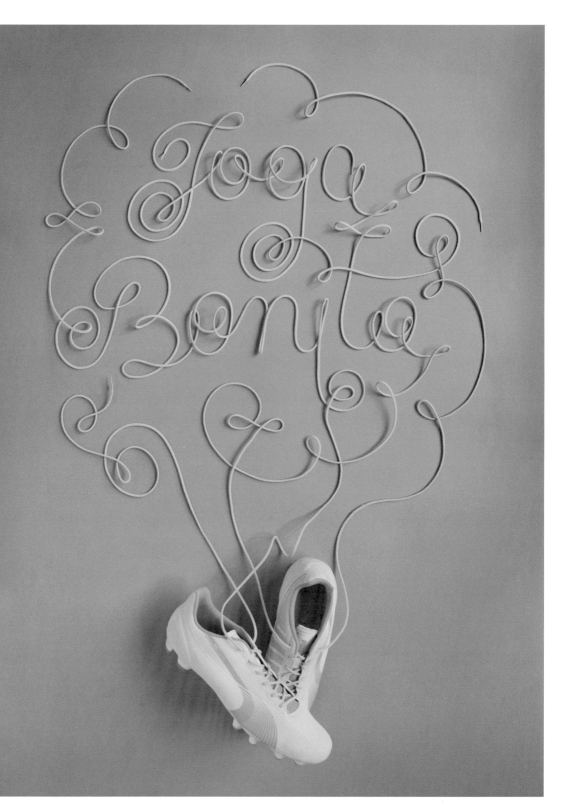

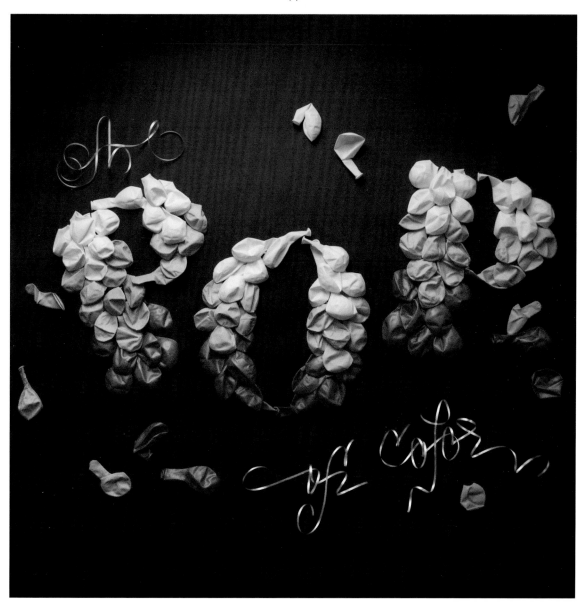

left: World Cup, **Danielle Evans** / right: Pop of Color, **Danielle Evans**

Mister GREN

www.facebook.com/ilmistergren

Mister GREN is an italo-norwegian graphomaniac. He has been always fashinated by letters and this led him to approach graffiti back in 1998. The passion grew and always trying to find new challenges started with calligraphy in 2008. The background from "underground culture" such as punk-rock, skate and graffiti set an attitude on how to look at art: have fun, diy and follow your path in an unconventional way. Between different experimentations he is the recognized pioneer within snow calligraphy, a project started in 2008 and still going on. Lately GREN is working on a personal handstyle mixing strict calligraphy's rules and graffiti onliners. GREN is a proud and chosen member of Calligraffiti Ambassador and supported by GROG markers and MONTANA cans.

He is not good with social media at all so if you want to check some of his work go to:
www.facebook.com/ilmistergren
www.youtube.com/user/MrGgraphomania

Mister GREN es un grafomaniaco ítalo-noruego. Siempre ha estado fascinado por la caligrafía y esto le llevó a interesarse en el graffiti allá por 1998. La pasión creció, y siempre tratando de encontrar nuevos retos empezó con la caligrafía en 2008. Su experiencia de la "cultura underground" como punk-rock, skate y grafiti asentaron una actitud respecto a como enfocar el arte: diviértete, hazlo tú mismo y sigue tu camino de forma no convencional. Entre distintas experimentaciones es reconocido como el pionero dentro de la caligrafía en nieve, un proyecto empezado en 2008 y todavía activo. Últimamente, GREN está trabajando en un estilo a mano personal mezclando normas caligráficas estrictas y grafiteros online. GREN es un miembro elegido y orgulloso de Calligraffiti Ambassador y es apoyado por marcadores GROG y latas MONTANA.

No se le dan nada bien las redes sociales así que si quieres echarle un ojo a algo de su trabajo accede a:
www.facebook.com/ilmistergren
www.youtube.com/user/MrGgraphomania

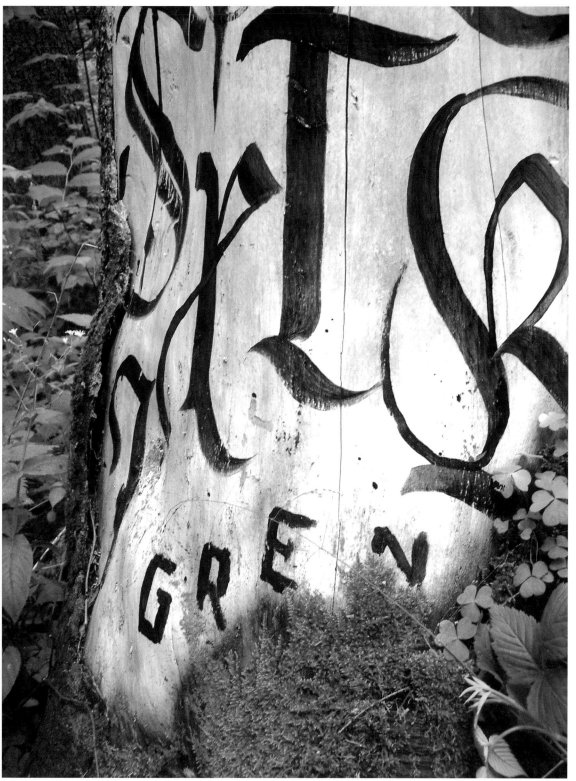

Under my skin, **Mister GREN**

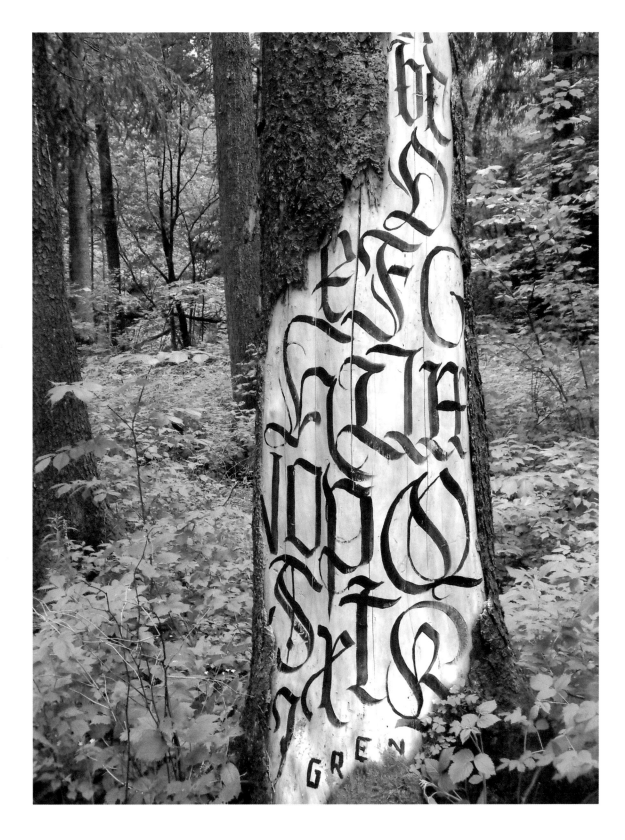

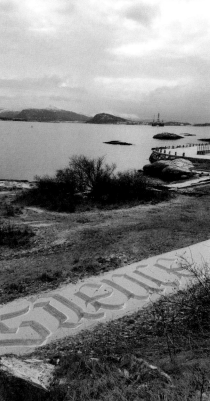

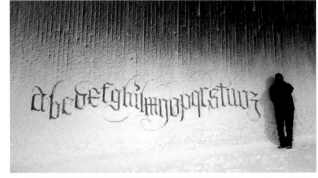

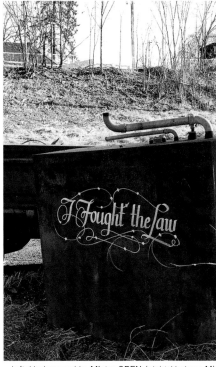

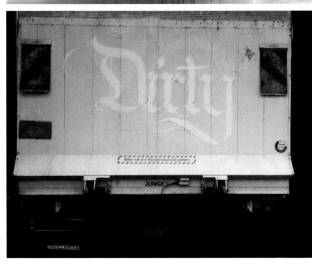

left: Under my skin, **Mister GREN** / right: Various, **Mister GREN**

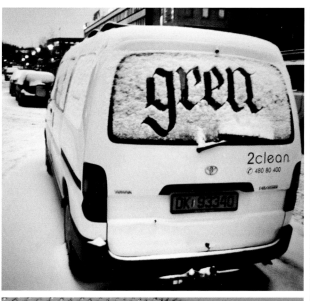

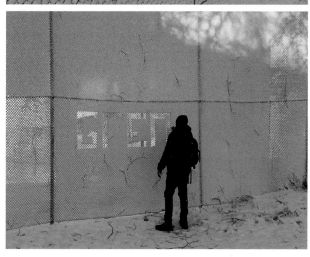

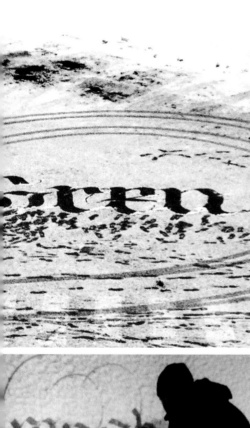
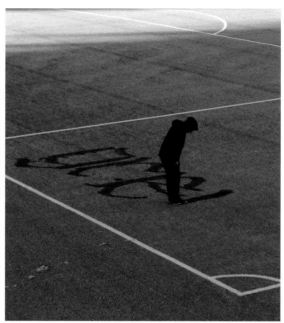
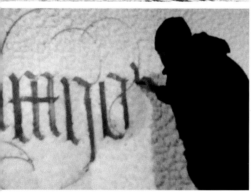
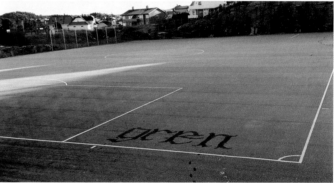
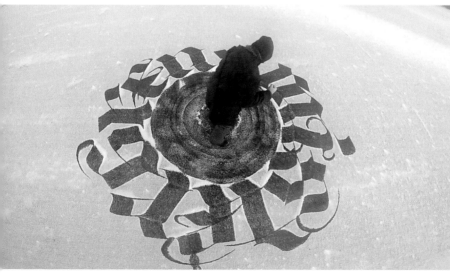

Mister GREN

Lobulo

www.lobulodesign.com

Lobulo had realised what he wanted to be when he grew up, while shopping with his mother at the supermarket. He would always make her pick the cereals for the picture on the cover, rather than for what was actually inside. Naturally, he ended up studying graphic design and marketing, learning that there's much more to a computer than just playing pacman.

A variety of unique, creative collaborations, as well as more than 10 years experience of working for various graphic design and marketing studios in Barcelona, have meant that he has filled the streets, and a few hard disks, with his designs, illustrations, editorial projects and concepts. Small or large, formal or informal, but always expressing emotions. Always sending out a message.

Lobulo se dio cuenta de lo que quería ser cuando fuera mayor mientras compraba con su madre en el supermercado. El siempre le hacía elegir los cereales dependiendo de la imagen en el cartón, antes que por lo que hubiera dentro. Naturalmente acabó estudiando diseño gráfico y marketing, aprendiendo que hay mucho más que hacer con un ordenador que jugar al Comecocos.

Una variedad de colaboraciones creativas únicas, al mismo tiempo que 10 años de experiencia trabajando para varios estudios de diseño gráfico y marketing en Barcelona, implican que haya llenado las calles y varios discos duros con sus diseños, ilustraciones, proyectos editoriales y conceptos. Pequeño o grande, formal o informal, pero siempre expresando emociones. Siempre enviando un mensaje.

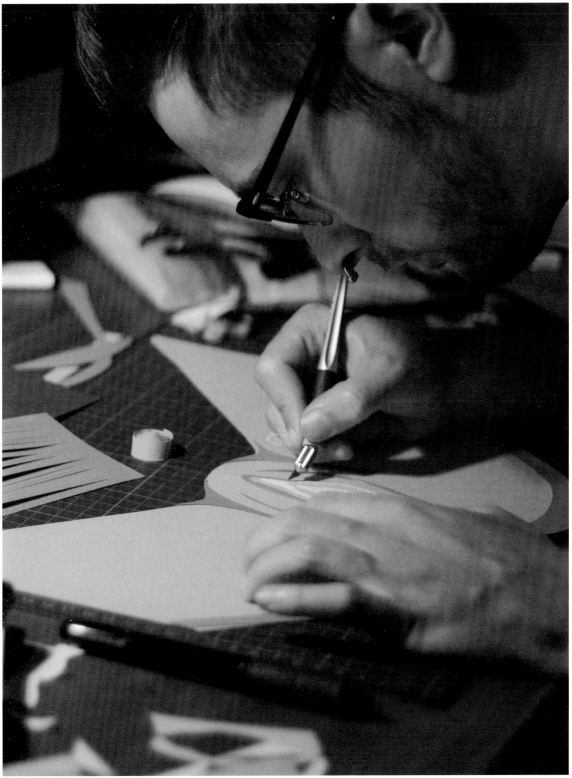

Lobulo

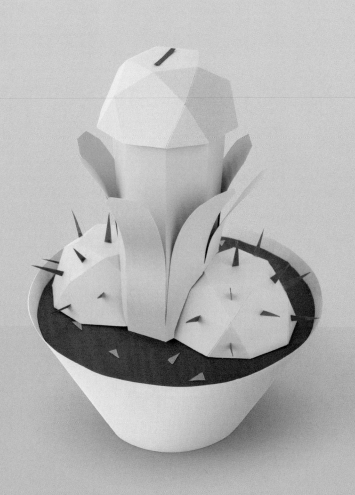

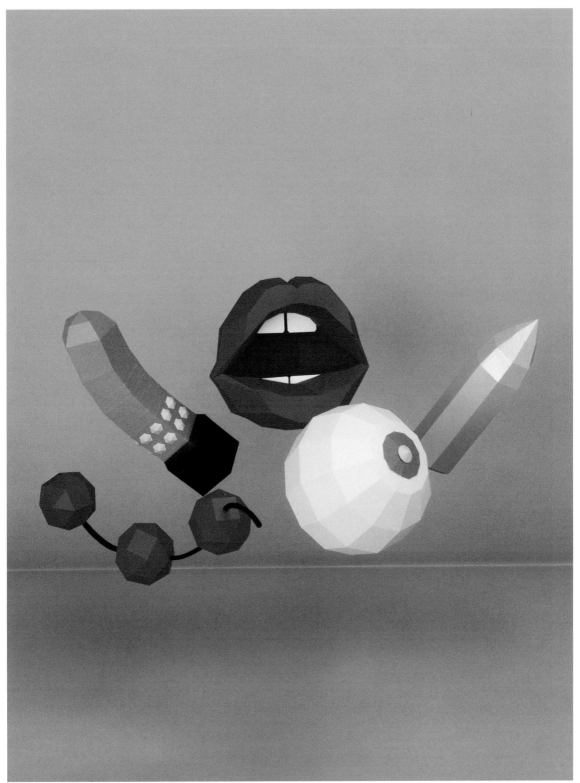

left: Don't be a pussy, **Lobulo** / right: Offf, **Lobulo**

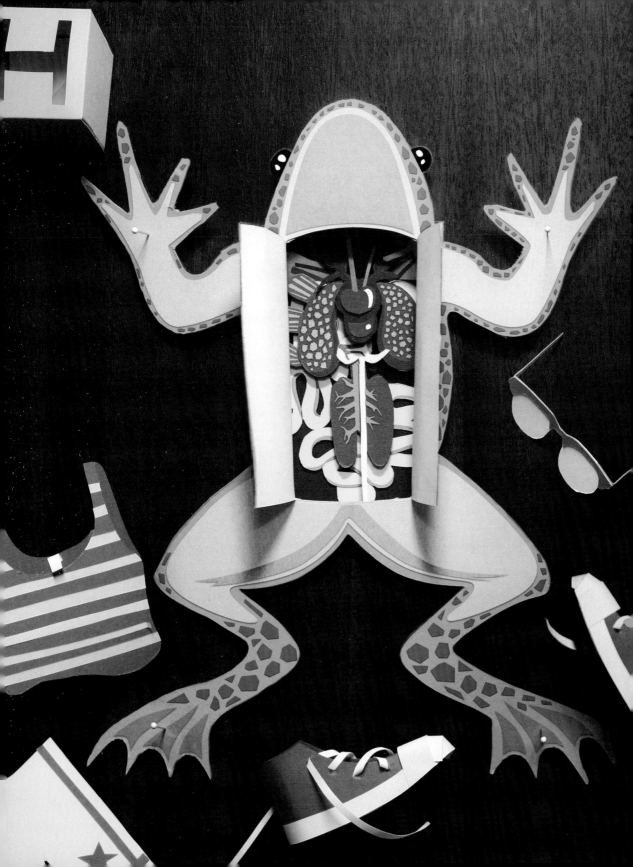

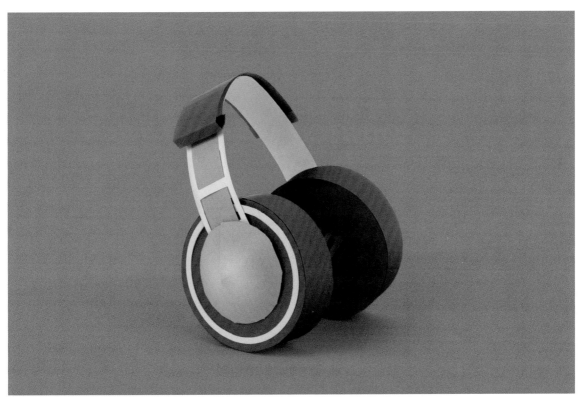

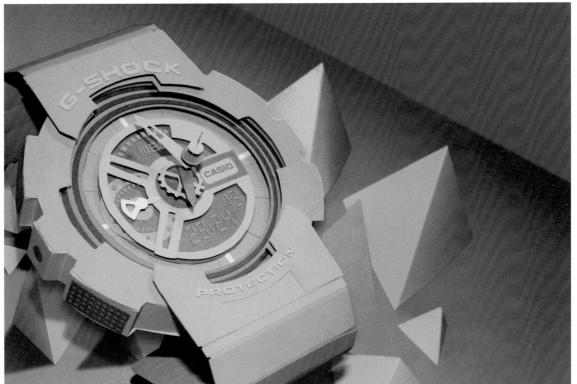

left: "H" Cover, **Lobulo** / right: top, Earphones, bottom, Casio, **Lobulo**

RIDE YOUR BIKE

left: top, Bike, bottom, Sneakers, **Lobulo** / right: Do Epic Shit, **Lobulo**

Briar Mark

www.briarleonimark.co.nz

Briar Mark graduated AUT University in 2011 with a Bachelor's Degree in Graphic Design. Her work is a continuation of her final project at university exploring the relationship between craft and design. Upon graduation her project was selected for the annual Best In Show exhibition at Objectspace Gallery, was a finalist in the 2012 New Zealand Best Design Awards and in 2013 was selected for an international craft exhibition in Munich, Talente. Briar is now working as a graphic designer at a small branding studio in Auckland.

Brian Mark se graduó en la Universidad de AUT en 2011 con una licenciatura en Diseño Gráfico. Su trabajo es una continuación de su proyecto final en la universidad, explorando la relación entre artesanía y diseño. Tras graduarse, su proyecto fue seleccionado para la exposición anual Best In Show Awards en Objectspace Gallery, finalista en los premios Best Desing Awards en Nueva Zelanda y en 2013 fue seleccionado para una exposición internacional de artesanía en Múnich, Talente. Briar trabaja ahora como diseñador gráfico en un pequeño estudio comercial en Aukland.

Overprint "A", Briar Mark

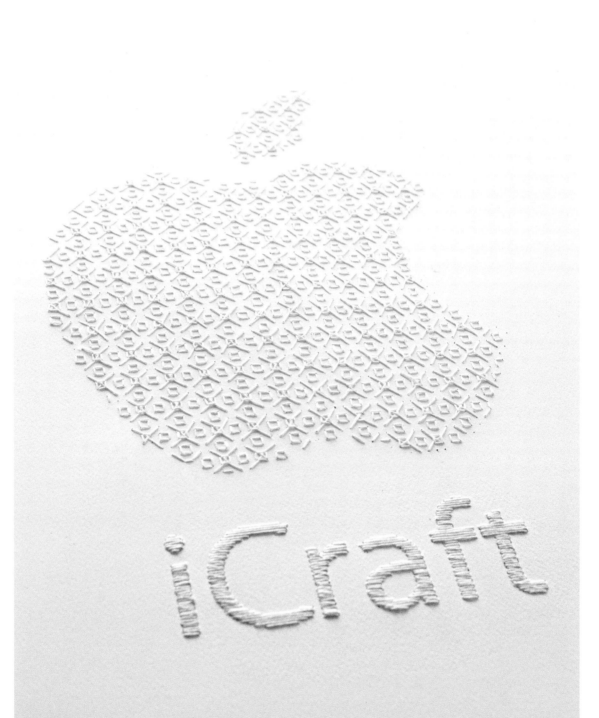

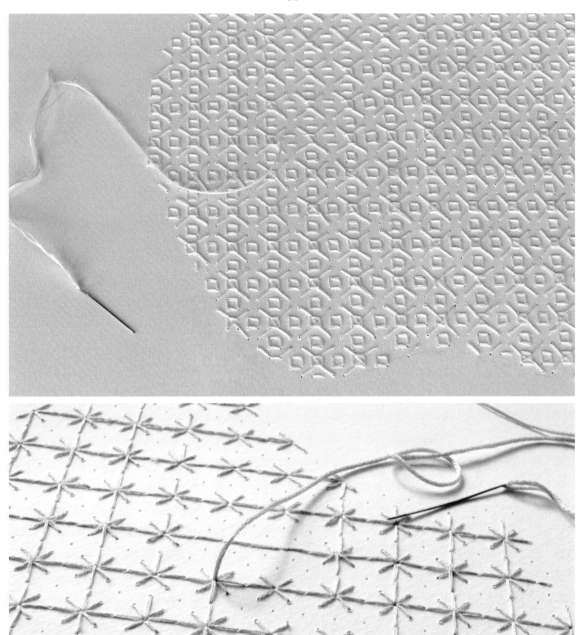

iCraft, Briar Mark

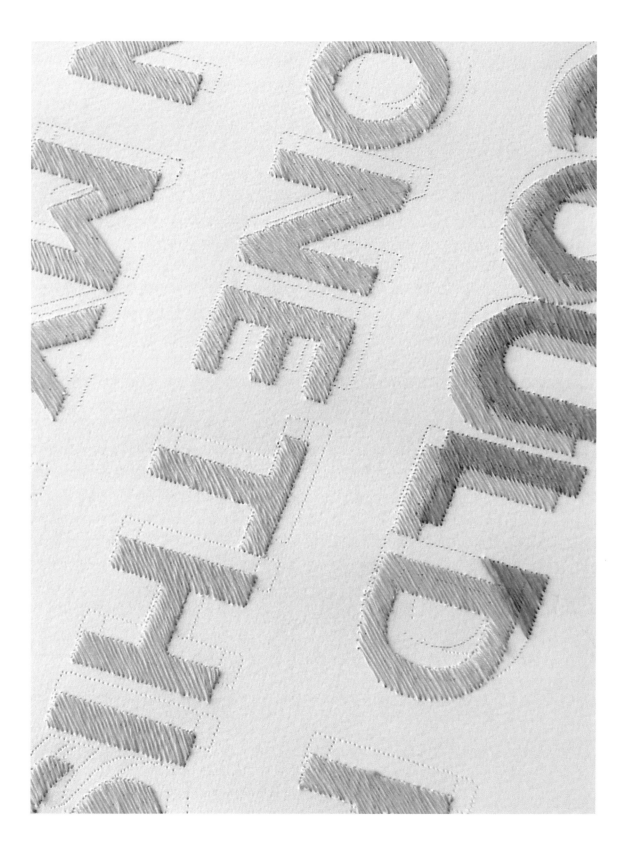

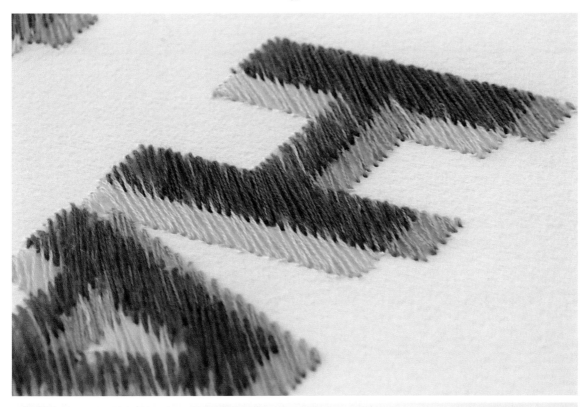

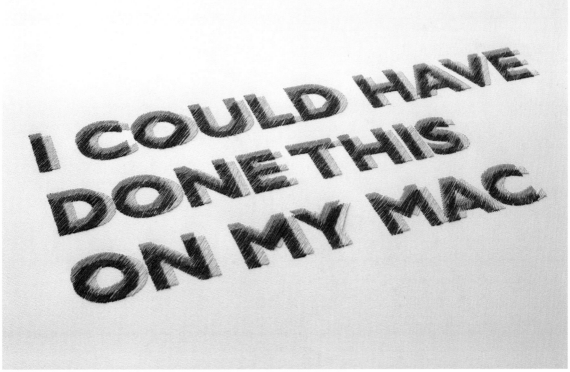

I could have done this on my mac, **Briar Mark**

Stitched pixels, the limitations of cross stitch are remarkably
similar to the limitations of the digital pixel.

Stitched QR code

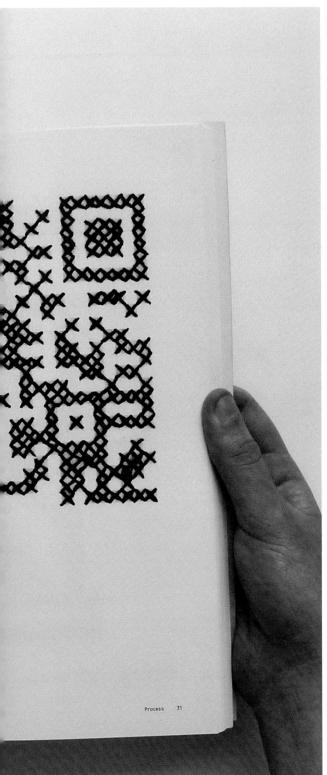

Process 31

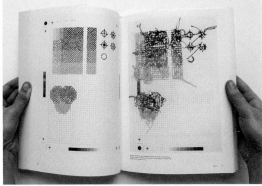

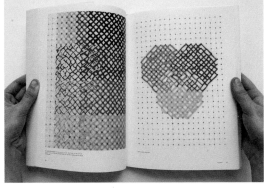

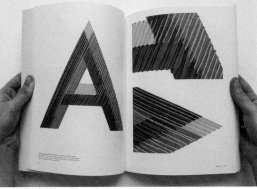

Process Book, Briar Mark

Danielle Clough

www.danielleclough.com

Born and raised in Cape Town, South Africa, Danielle Clough completed her studies in art direction and graphic design at The Red and Yellow School before embarking on a career in visual art, digital design and thing-making.

Her combined interest in visual art, music and South African street culture scene found Danielle creating visuals for live music events using the stage name Fiance Knowles and documenting her surroundings though photography. While always interested in fashion and sewing she taught herself to embroider.

Celebrating color Danielle reinterprets her photographs with threads and wool onto any surface she can find, from recycled coffee bags to rackets.

Nacida y criada en Ciudad del Cabo, Sudáfrica, Danielle Clough completó sus estudios en dirección artística y diseño gráfico en The Red and Yellow School antes de embarcarse en una carrera en arte visual, diseño digital y thing-making.

Su interés combinado en el arte visual, la música y la cultura callejera de la escena sudafricana, lo encontró Danielle creando visuales para eventos de música en directo usando el nombre artístico de Fiance Knowles, y documentando su entorno a través de la fotografía. Mientras, estuvo siempre interesada en la moda y la costura, aprendió ella misma a bordar.

Celebrando el color, Danielle reinterpreta sus fotografías con hilo y lana en cada superficie que puede encontrar, desde bolsas de café recicladas a raquetas.

Danielle Clough

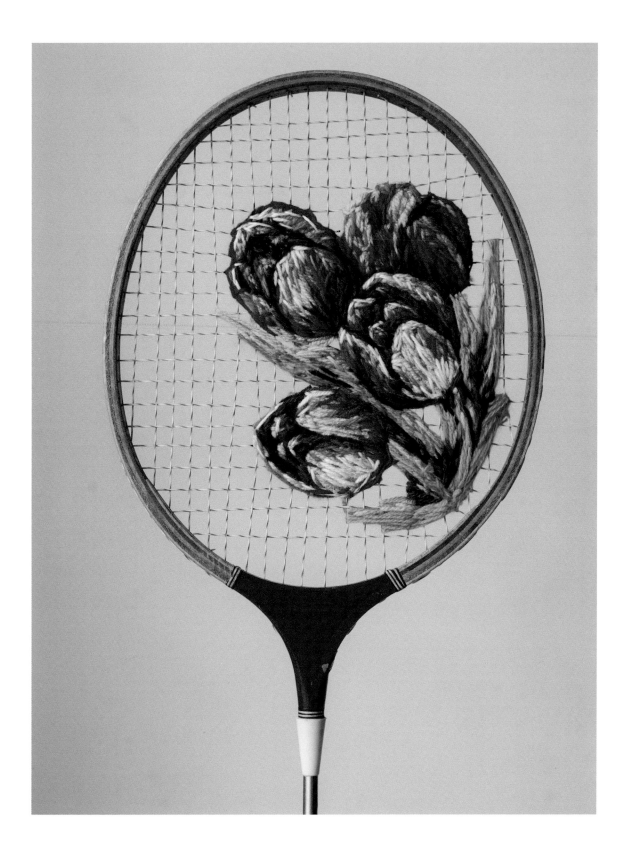

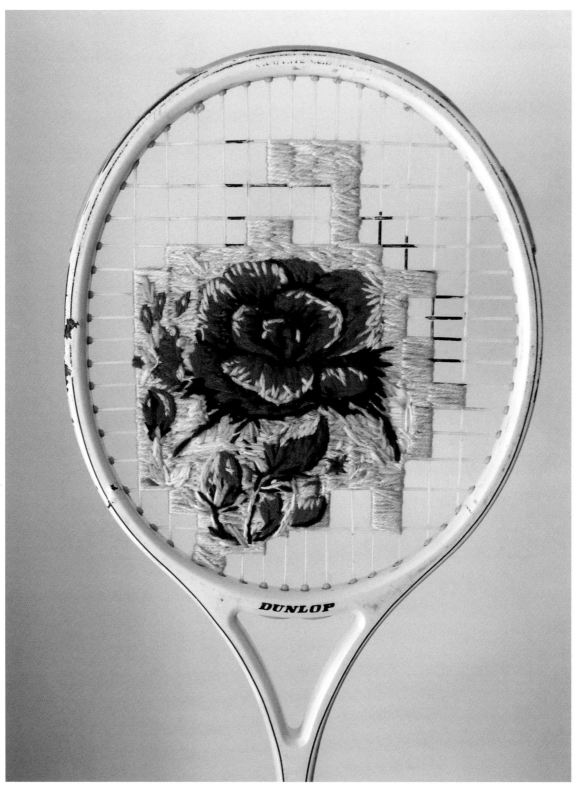

left: What a racket tulip, **Danielle Clough** / right: What a racket, **Danielle Clough**

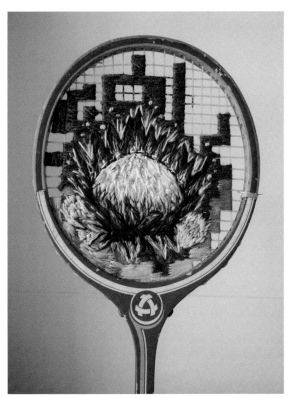
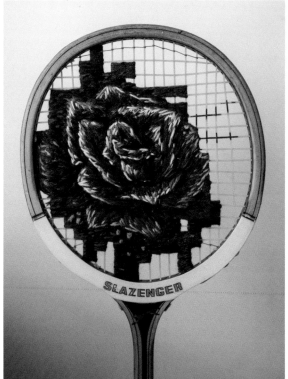
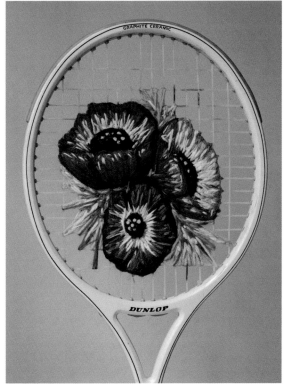

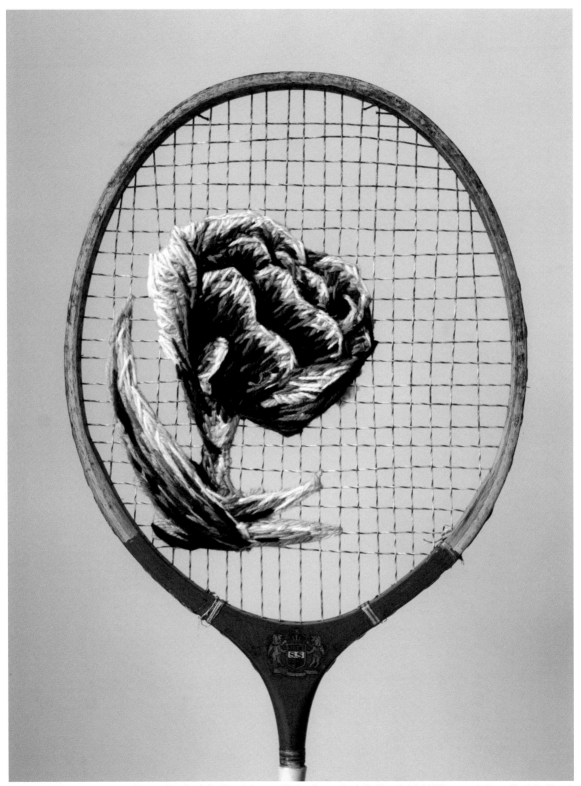

left: top, What a racket paper, Rose racket, **Danielle Clough** bottom, Racket Poppy, **Danielle Clough** / right: What a racket rose, **Danielle Clough**

Javier de Riba

www.javierderiba.com

A creative catalan designer and artist born in Barcelona, Javi has worked at various agencies and studios in the role of Art Director. Nowadays, he works as part of the Reskate Arts & Crafts Collective, who develop graphics and communication projects with a focus on sustainability and humane treatment. With each new endeavour, his restlessness brings him to question his personal style, and reinterpret it to best serve each project. For Javi, each piece challenges his aesthetic, driving him to try new styles and techniques while balancing his existing abilities with his desire for growth and exploration. His journey is an ongoing battle against stagnancy, in favour of versatility and innovation.

Creativo, artista y diseñador catalán nacido en Barcelona. Ha trabajado en varios estudios y agencias como director de arte. Actualmente forma parte del colectivo Reskate Arts & Crafts con el que desarrolla proyectos gráficos y comunicativos ligados a la sostenibilidad y el trato humano. Con cada nuevo esfuerzo su inquietud le lleva a cuestionar su estilo personal en cada proyecto para ponerlo al servicio de la comunicación. Para él cada pieza pide su estética y se aventura a probar nuevas técnicas y estilos con más o menos virtud. Una lucha constante contra el estancamiento, en favor de la versatilidad.

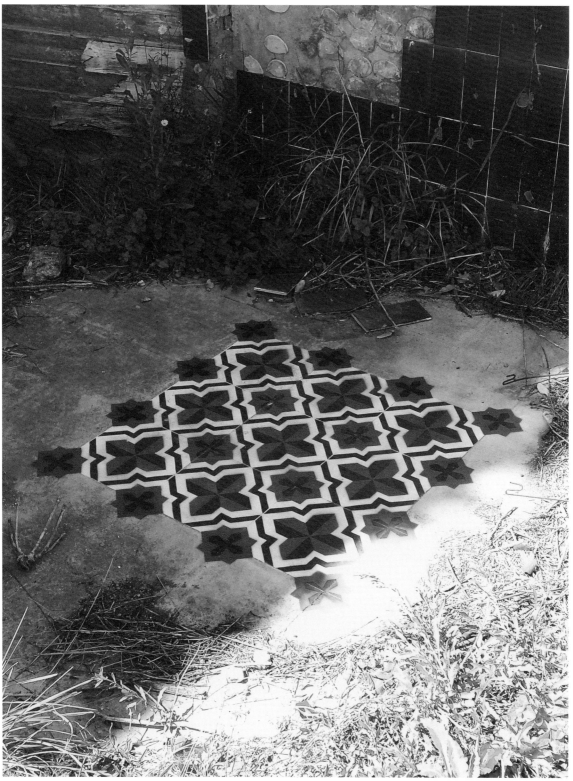

Floors: Oreneta pattern, **Javier de Riba**

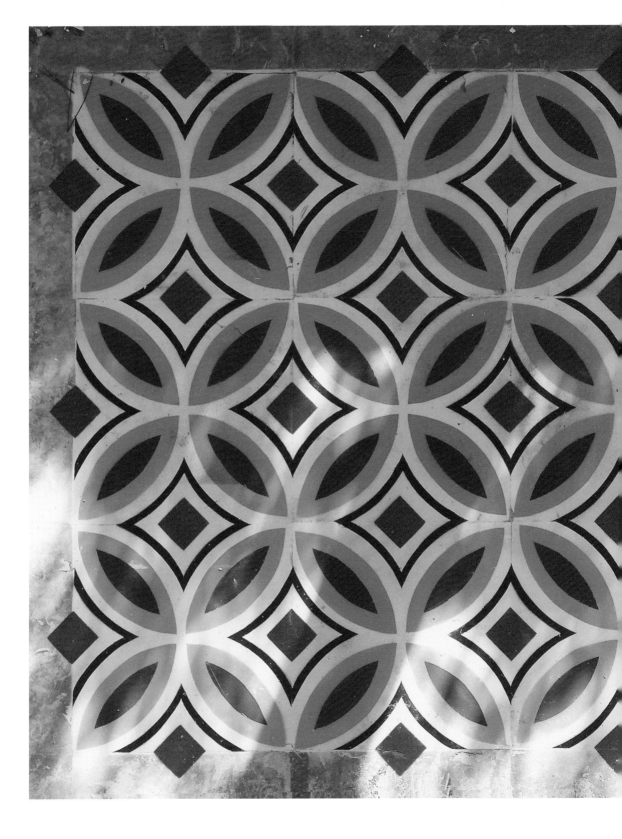

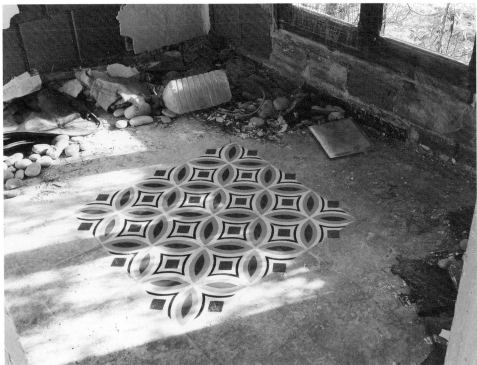

In this project Javier locates abandoned, grey floors and acts on the surface with patterns. He works on the support skin, layer by layer, covering and uncovering it. This way, his intervention gets mixed with the manifestation that this was already there.

Each tile has the same drawing but with the repetition new shapes are generated emanating from the intersections/joints of the tiles.

En este proyecto Javier localiza suelos abandonados, grises, y interviene con patrones la superficie. Trabaja la piel del soporte, por capas, cubriendo y descubriendolo. De este modo su intervención se mezcla con la manifestación de eso que ya estaba allí.

Cada baldosa tiene el mismo dibujo pero con la repetición se generan nuevas formas que nacen en las intersecciones/ junturas de las baldosas.

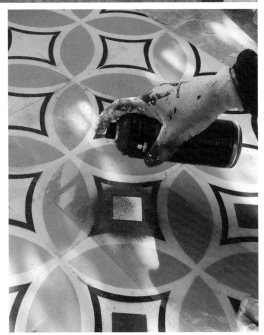

Floors: Bungalow pattern, **Javier de Riba**

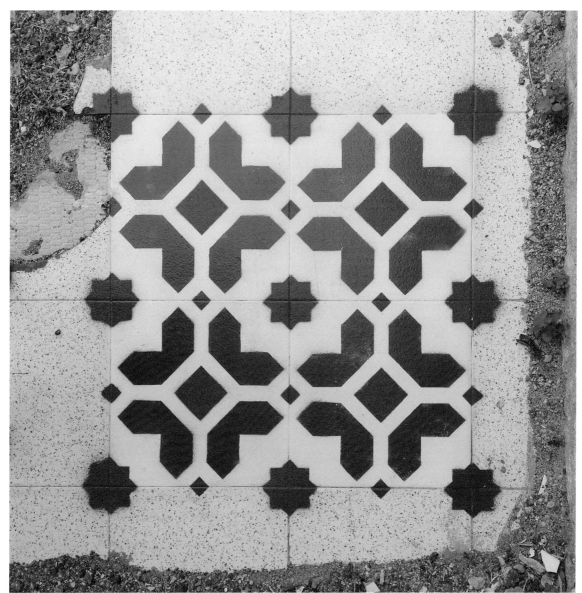

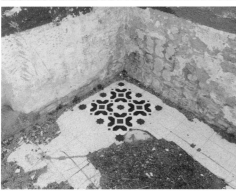

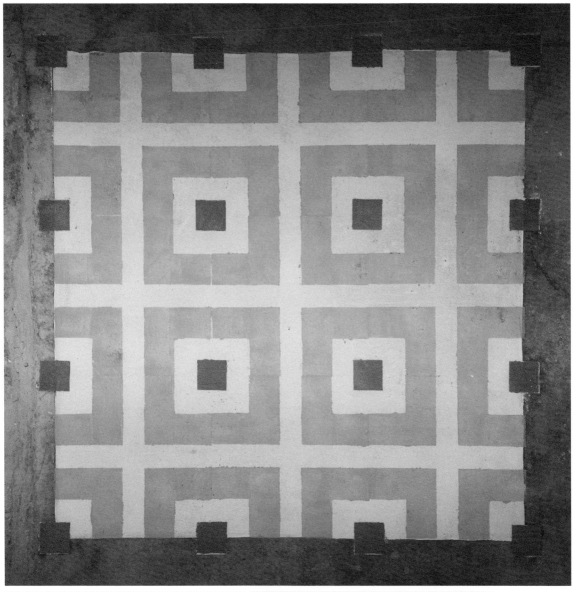

 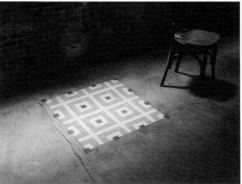

left: Floors: Colònia Castells, **Javier de Riba** / right: Floors: Karratuak pattern, **Javier de Riba**

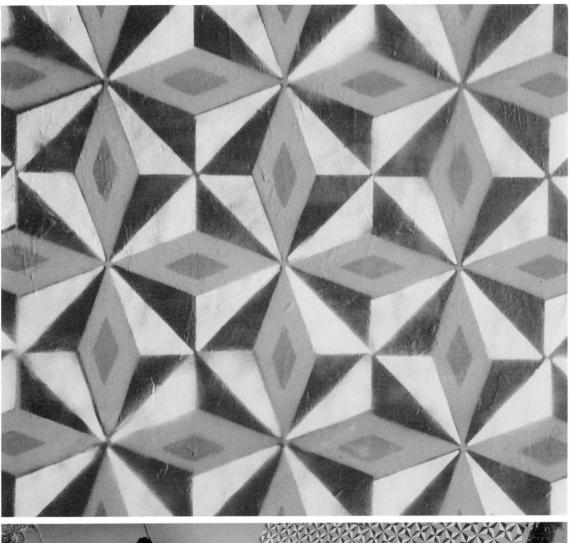

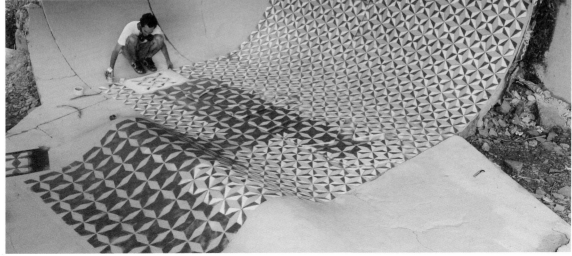

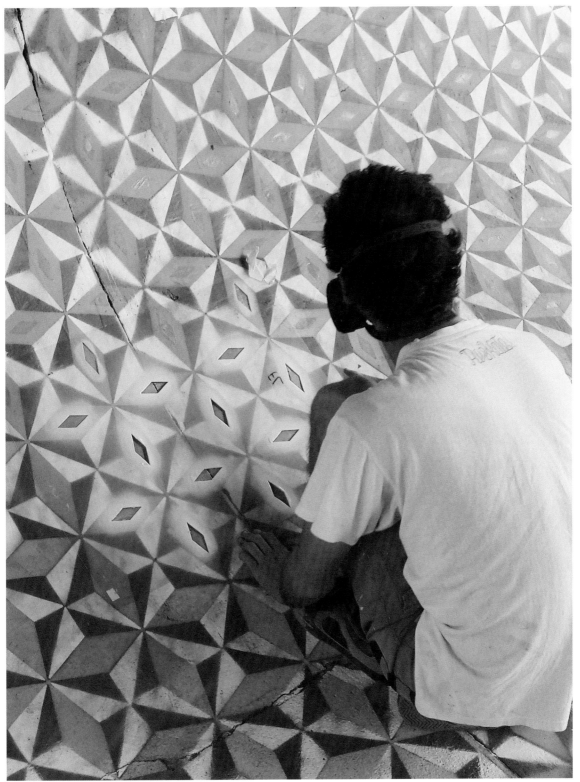

Floors: Hütteldorf, **Javier de Riba**

Reskate Arts & Crafts

www.reskatestudio.com

Reskate Arts&Crafts is a design study and workshop in Barcelona which produces projects with an artisanal character. It is formed by Javier de Riba (1985) and Maria Lopez (AK: minuskula) (1980), graphic designers and illustrators from Barcelona and Donostia-San Sebastian respectively. They produce graphic art, illustration, installations and murals.

From their studio they try to help with projects in what regards graphics, contributing their characteristic manual take, benefiting from the means at their reach.

As an artistic group they are interested in focusing on the materials to take the most of expression possible out of them. They firmly believe that the choice of the milieu shouldn't be superfluous and must be put at the service of the message to amplify it.

Reskate Arts&Crafts es un estudio gráfico y taller de Barcelona que produce proyectos de carácter artesanal. Está formado por Javier de Riba (1985) y María López (AKA: minuskula) (1980), diseñadores gráficos e ilustradores de Barcelona y Donostia-San Sebastián respectivamente. Realizan diseño gráfico, ilustración, instalaciones y muralismo.

Desde su estudio tratan de servir gráficamente a proyectos con el trato manual que les caracteriza aprovechando los medios que tienen a su alcance.

Como colectivo artístico les interesa centrarse en los materiales para sacarles la mayor expresividad posible. Creen firmemente que la elección de un medio no debe ser superflua y debe estar al servicio del mensaje para amplificarlo.

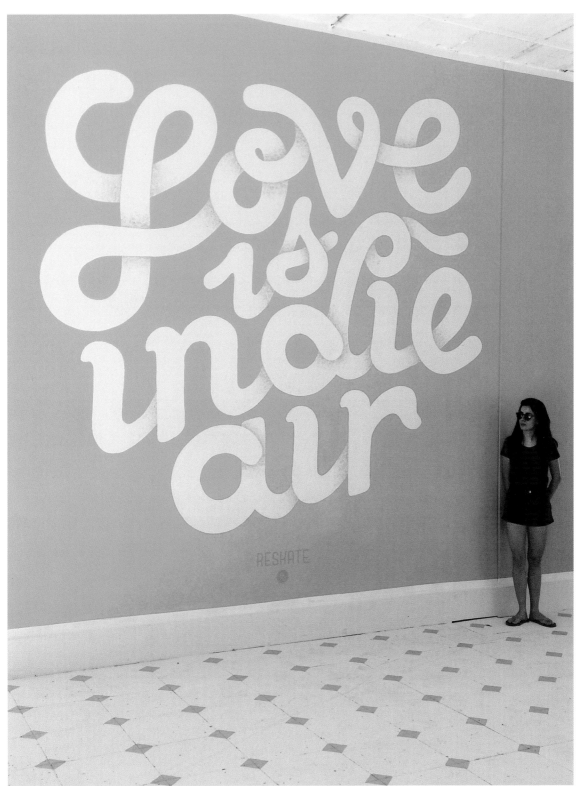

Love is indie air, **Reskate Arts & Crafts**

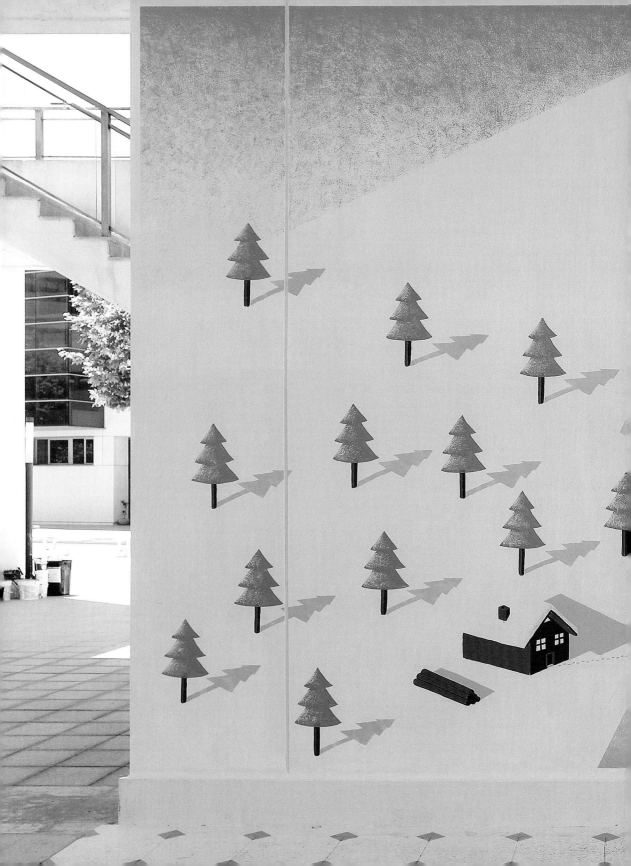

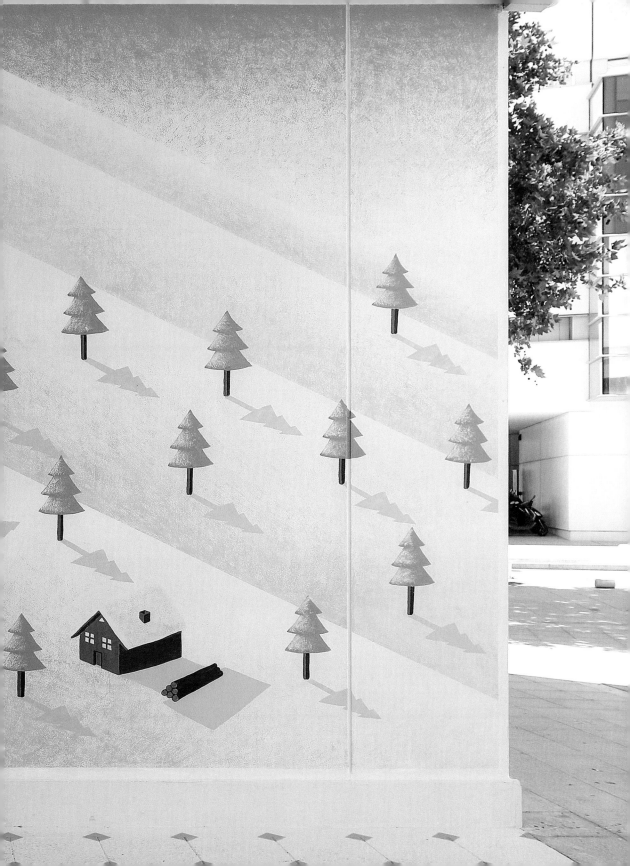

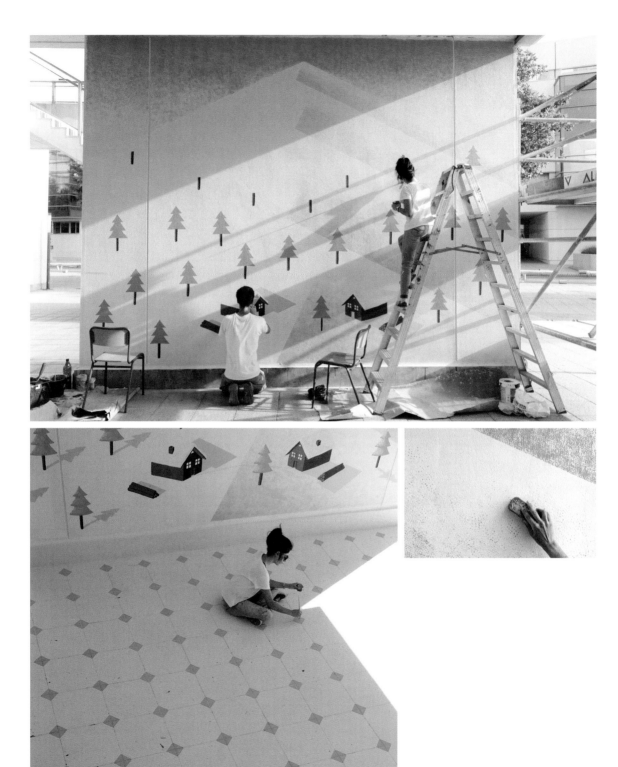

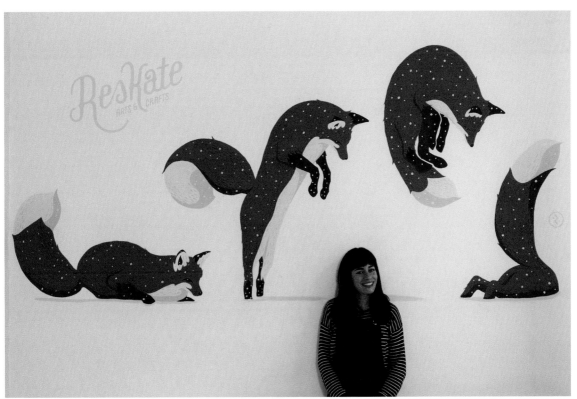

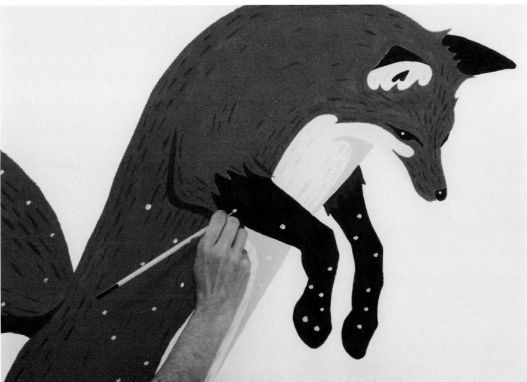

left: Love is indie air, **Reskate Arts & Crafts** / right: Fox Diving, **Reskate Arts & Crafts**

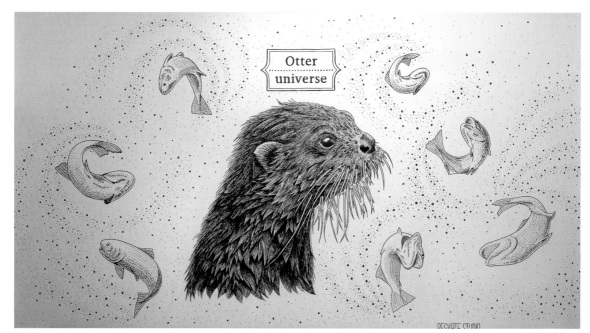

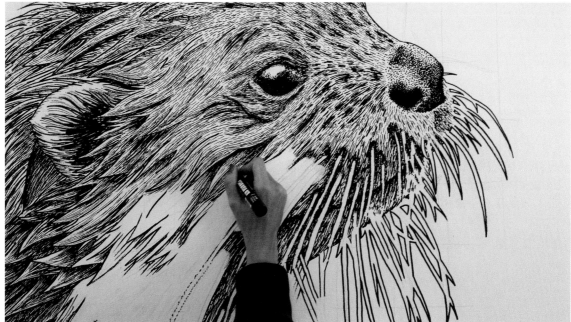

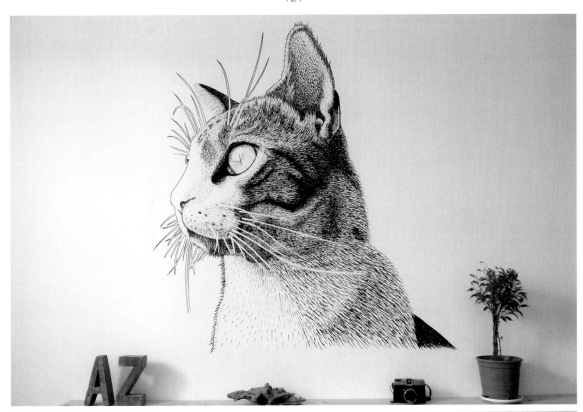

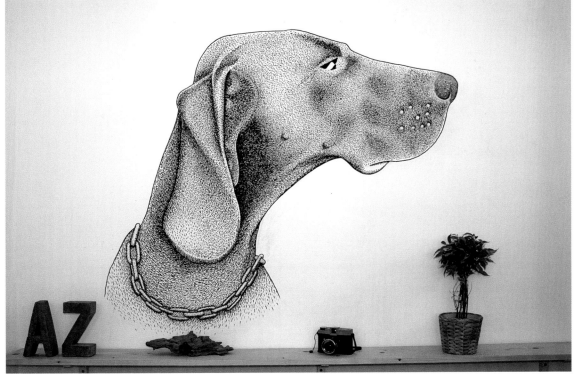

left: Otter Universe, **Reskate Arts & Crafts** / right: top, Gattero, **Reskate Arts & Crafts** bottom, Una, **Reskate Arts & Crafts**

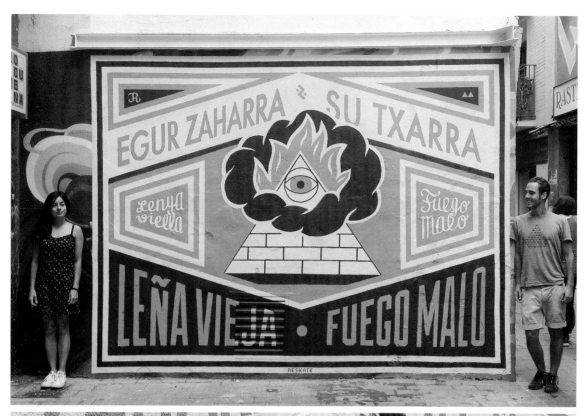

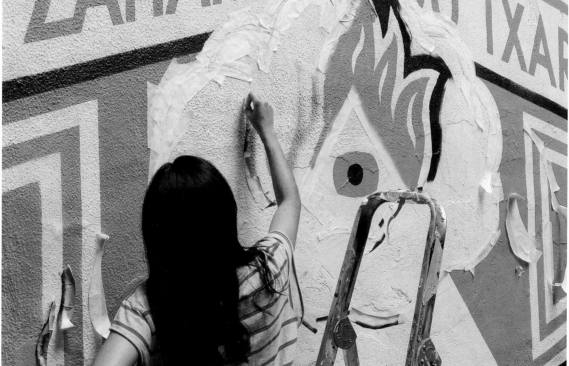

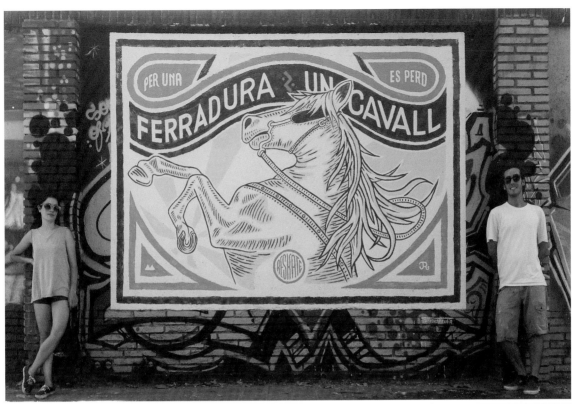

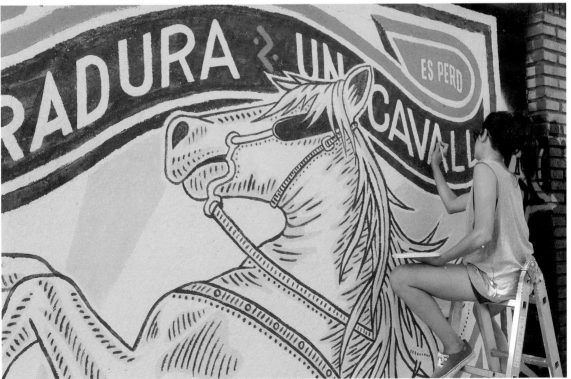

left: Egur zaharra, **Reskate Arts & Crafts** / right: Per una ferradura, **Reskate Arts & Crafts**

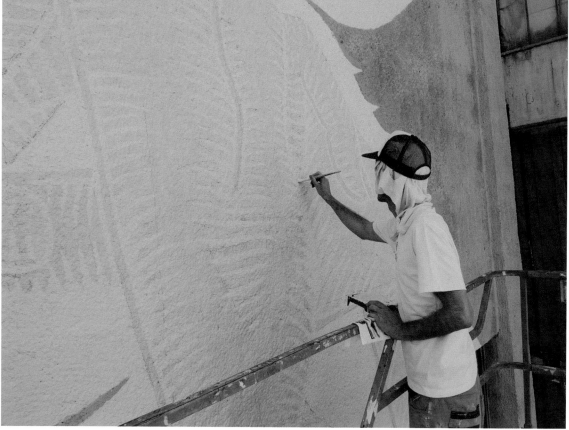

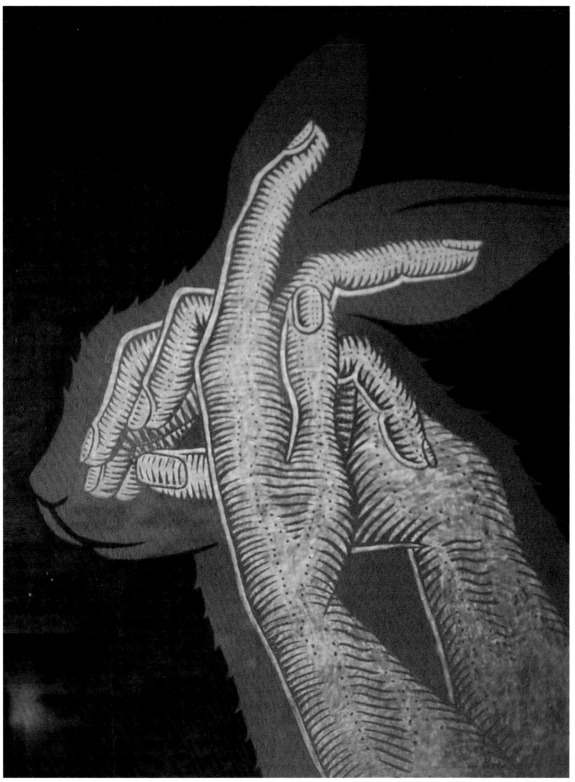

Harreman, Reskate Arts & Crafts

Sean Sullivan

seansullivanstudios.com

Sean Sullivan is an interdisciplinary artist whose practice includes a combination of drawings, animations and interactive sculpture. He is perhaps best known for his sprawling murals and intricately detailed works on paper that weave a dense tapestry of imagery, and textures. His work borrows from a diverse pool of visual languages, among them classical landscape etchings, botanical and anatomical diagrams, computer simulations – generally any representations that aid in describing the dimensional world. His drawing process is fluid, often working from one corner and building outward, improvising and adapting to what has already been put down.

Sean Sullivan is currently the Creative Director at The incite group in Los Angeles California. He received a BFA from Art Center College of Design in 2005, and an MFA from the University of California Irvine in 2009. Public art projects include "Earth and Sky" a group installation at Los Angeles International airport. He has exhibited at The Luckman Gallery at Cal State Los Angeles, LA><ART in Culver City, Lora Schlesinger gallery Santa Monica, and Steve Turner Contemporary in Los Angeles. He has led drawing courses at Southern California Institute of Architecture, and The Norton Simon Museum in Pasadena.

Sean Sullivan es un artista interdisciplinar cuya práctica incluye una combinación de dibujos, animaciones y escultura interactiva. Quizás es más conocido por sus extensivos murales y sus trabajos intrincadamente detallados en papel que hacen ondear un denso tapiz de imaginería y texturas. Su trabajo toma prestado lenguajes visuales de fuentes diversas, entre ellas grabados paisajísticos clásicos, diagramas botánicos y anatómicos, simulaciones informáticas, de forma general cualquier representación que ayude a describir el mundo dimensional. Su proceso de dibujo es fluido, a menudo trabajando desde un rincón y construyendo hacia fuera, improvisando y adaptándose a lo que ya se ha fijado.

Sean Sullivan es actualmente el Director Creativo en The Incite Group en Los Ángeles, California. Ha recibido un grado en Bellas Artes del Art Centre College of Design en 2005, y un máster en Bellas Artes de la Universidad de California en Irvine en 2009. Sus proyectos de arte públicos incluyen "Tierra y Cielo" una instalación grupal en el Aeropuerto Internacional de Los Ángeles. Ha expuesto en la Galería Luckman en Cal State, Los Ángeles, LA><ART en Culver City, la galería Lora Schlesinger en Santa Mónica, y Steve Turner Contemporary en Los Ángeles. Ha dirigido cursos de dibujo en el Instituto de Arquitectura Southern California, y el Museo Norton Simon en Pasadena.

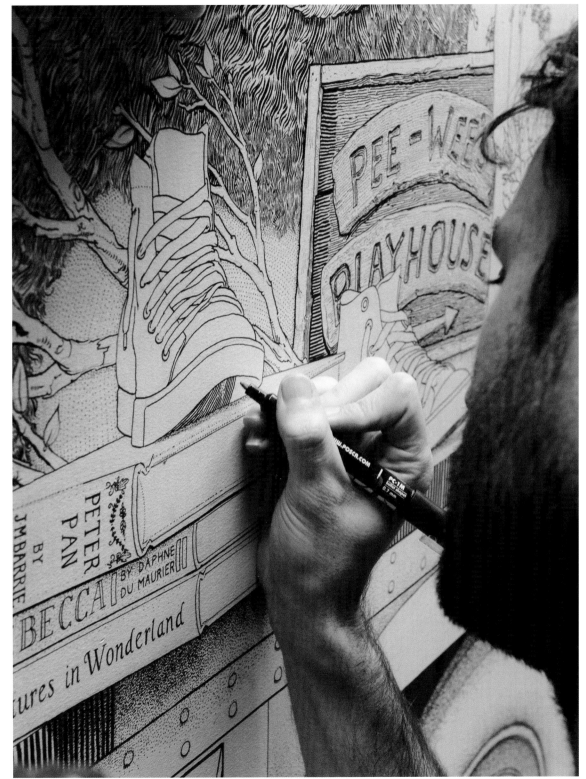

Culver Studios Trailer (2,7mx4,3m) 2015 in Collaboration with Lucy Hamblin, **Sean Sullivan**

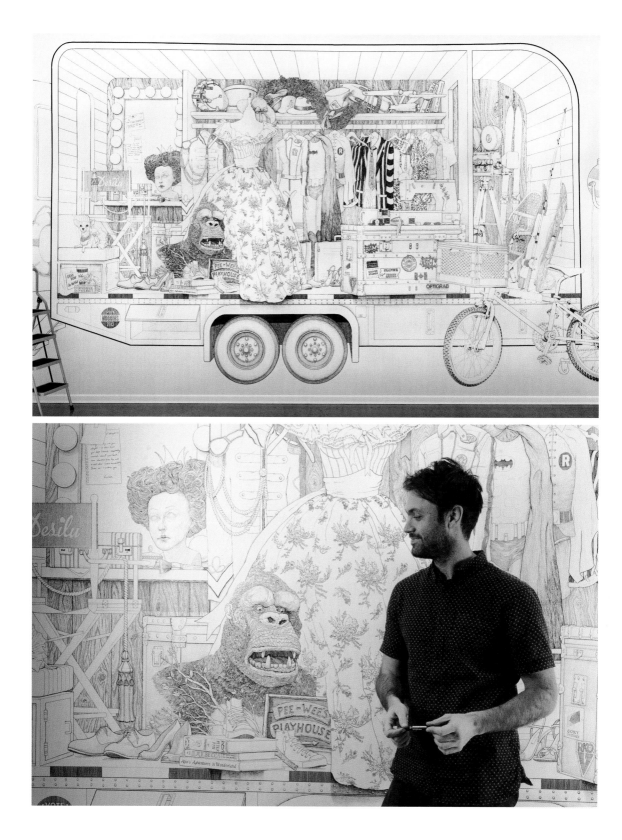

Culver Studios Trailer (2,7x4,3 m) 2015 in Collaboration with Lucy Hamblin, **Sean Sullivan**

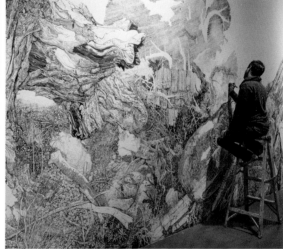

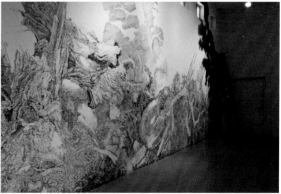

Grand Pale Maw (4,5x11 m) 2012, **Sean Sullivan**

Sara Landeta

www.saralandeta.com

Sara Landeta has graduated on illustration on the art school number 10 of Madrid. She has worked as an illustrator for brands such as Peugeot, US Cellular, Volkswagen and Springfield among others. In 2001 she starts to develop her artistic career and is represented up to now by the gallery 6mas1 (Madrid), with which she has carried out her three individual exhibitions to the present moment, "Of bears", "Growing slowly" and "Medicine as metaphor". She has also had, during these years, exhibitions in national and international festivals. Her work channels a variety of topics always related to the symbology of nature, the forest-like fight and the forest inside each of us. The creation of metaphors from the links she establishes between her drawings and the constant idea of giving priority to the paper, leaving aside the idea that this is only a material in which to draw, she tries to use it in a way that provides a new meaning and a new language to her works.

Sara Landeta es licenciada en ilustración por la escuela de arte número 10 de Madrid. Ha trabajado como ilustradora para marcas como Peugeot, US Cellular, Volkswagen y Springfield entre otras. En 2001 comienza a desarrollar su carrera artística y es representada hasta el momento por la galería 6mas1 (Madrid), con quién ha llevado a cabo sus tres exposiciones individuales hasta el momento, "De los úrsidos", "Crecer despacio" y "Medicine as metaphor". También ha expuesto durante estos años en ferias nacionales e internacionales. Su trabajo canaliza diversos temas relacionados siempre con la simbología de la naturaleza, la lucha selvática y el bosque interior de cada uno. La creación de metáforas a partir de los vínculos que establece entre sus dibujos y la idea constante de darle prioridad al papel, dejando de lado la idea de que este solo es un soporte sobre el que dibujar, trata de utilizarlo de manera que aporte un nuevo significado y un nuevo lenguaje en sus obras.

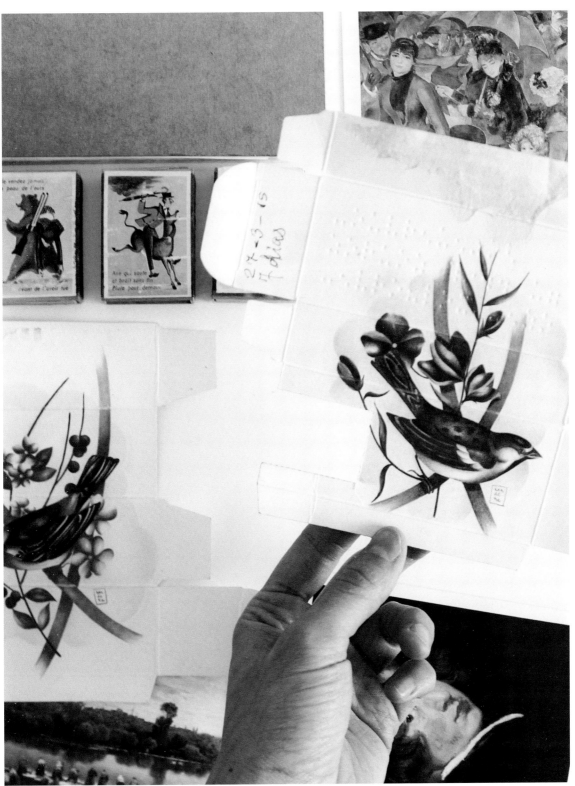

Sara Landeta

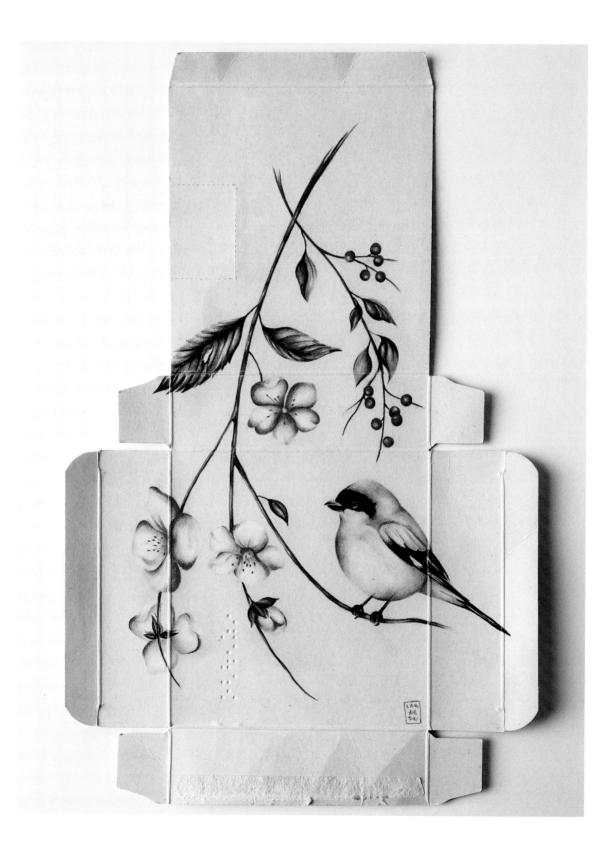

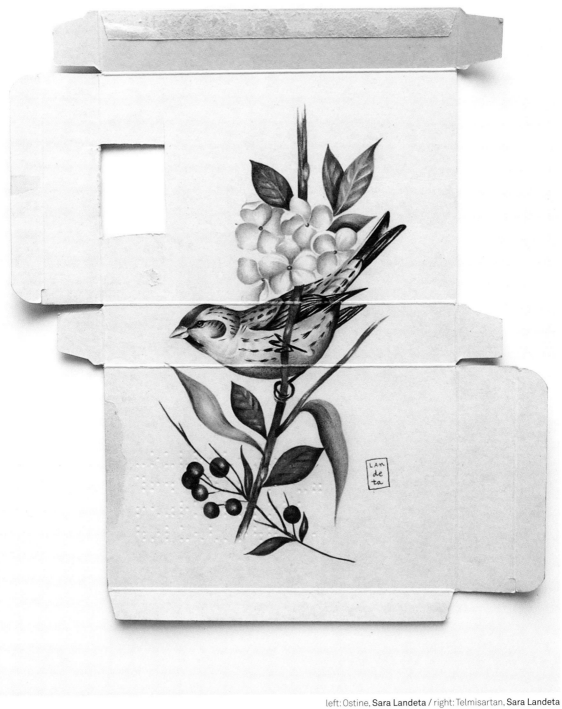

left: Ostine, **Sara Landeta** / right: Telmisartan, **Sara Landeta**

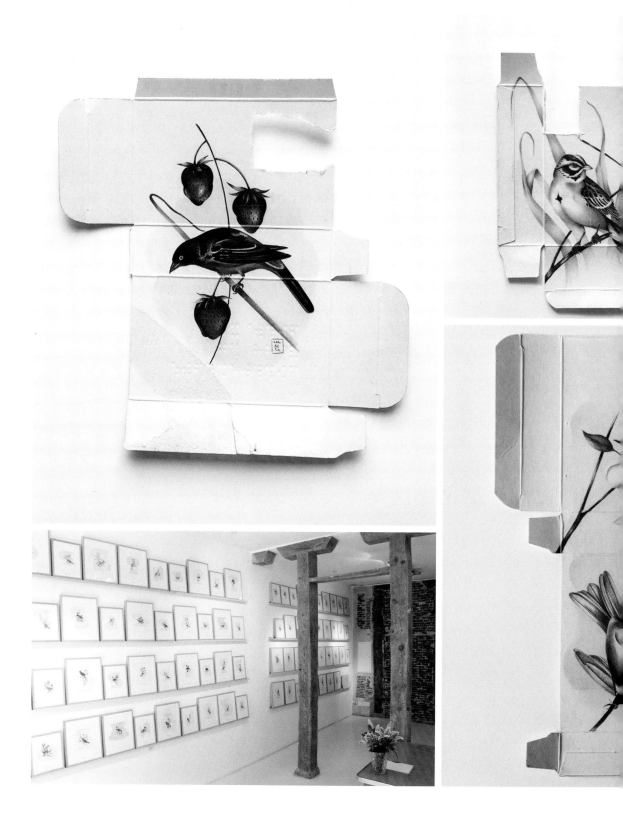

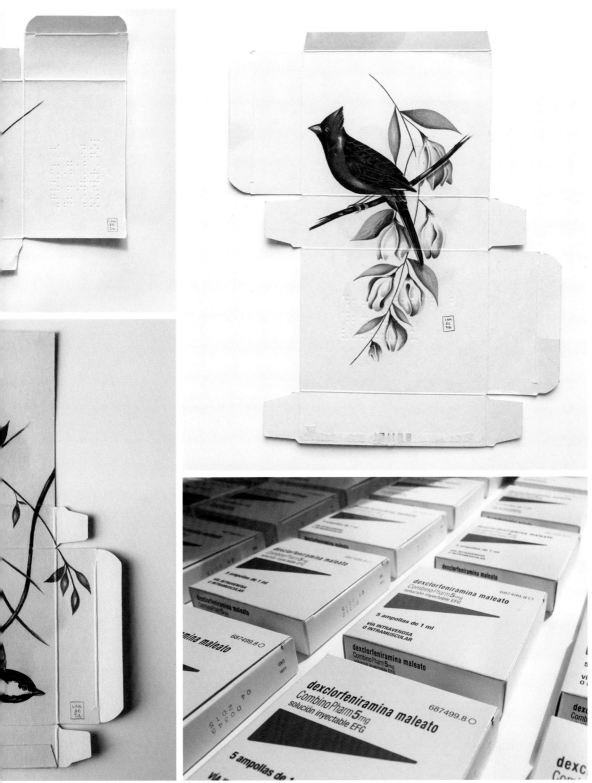

left: top, Deprax, Omeprazol, bottom, dexclorferinamina, **Sara Landeta** / right: Pepticum, **Sara Landeta**

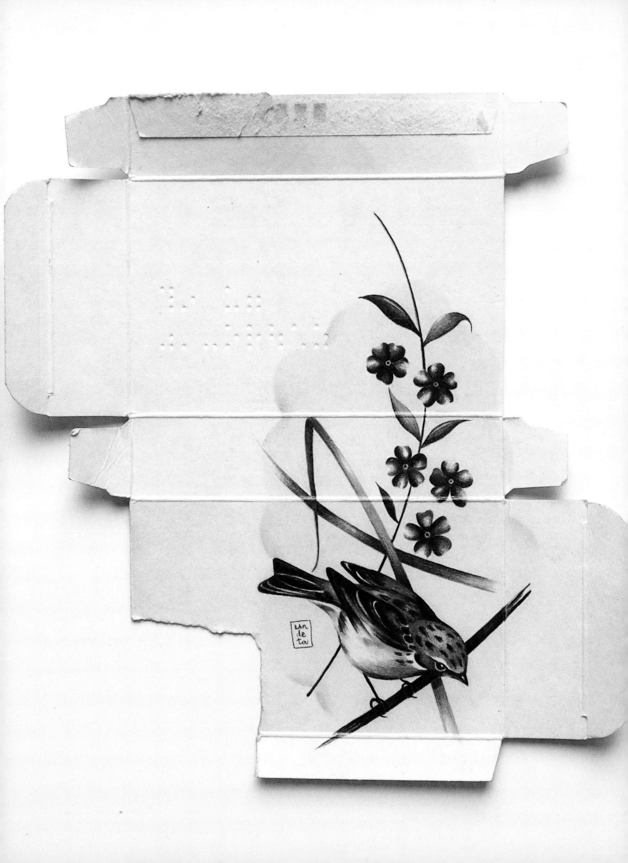

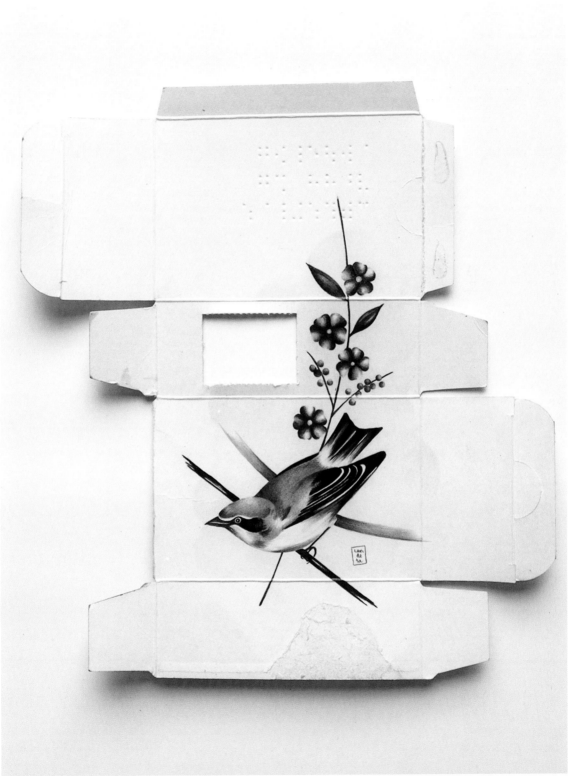

left: Darcotin, **Sara Landeta** / right: Artilog, **Sara Landeta**

David Fullarton

www.davidfullarton.com

David Fullarton is a Scottish born, San Francisco based visual artist. He keeps notebooks filled with scraps of paper, scribbled phrases, and other ephemera that he incorporates into his artwork. These elements represent the often overlooked stuff of daily life, which is the root of Fullarton's inspiration. He sees beauty in the ways people manage to find joy and meaning in the minutiae. The artist paints vibrantly complex canvases whose elements jumble and mix together in a facsimile of modern life. Fullarton compliments these with smaller mixed media drawings on paper. These paper works are sometimes the genesis of the finished paintings, but are more often stand-alone vignettes featuring forlorn characters who find themselves in compromising situations. More examples of his work can be found at davidfullarton.com.

David Fullarton es un artista visual nacido en Escocia y con sede en San Francisco. Mantiene cuadernos de notas llenos de trozos de papel, frases garabateadas, y otros recuerdos que incorpora a su trabajo. Estos elementos representan las cosas de la vida cotidiana que a menudo pasamos por encima, que son la raíz de la inspiración de Fullarton. El ve belleza en las maneras que la gente encuentra para hallar felicidad y significado en lo cotidiano. El artista pinta lienzos vibrantemente complejos cuyos elementos se revuelven y mezclan juntos en un facsímil de vida moderna. Fullarton complementa estos con dibujos más pequeños de medios de comunicación mezclados y en papel. Estos trabajos en papel son a veces la génesis de las pinturas terminadas, pero más a menudo, son viñetas individuales mostrando caracteres desolados que se encuentran a sí mismos en situaciones comprometidas. Se pueden encontrar más ejemplos de su trabajo en davidfullarton.com.

With friends like these (40x30 cm) 2013, **David Fullarton**

left: The way things are (60x76 cm) 2014 , **David Fullarton** / right: Small things, **David Fullarton**

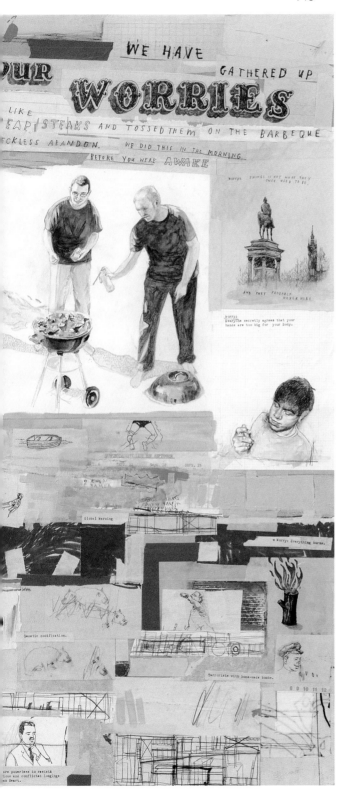

Wondrous Plan, David Fullarton

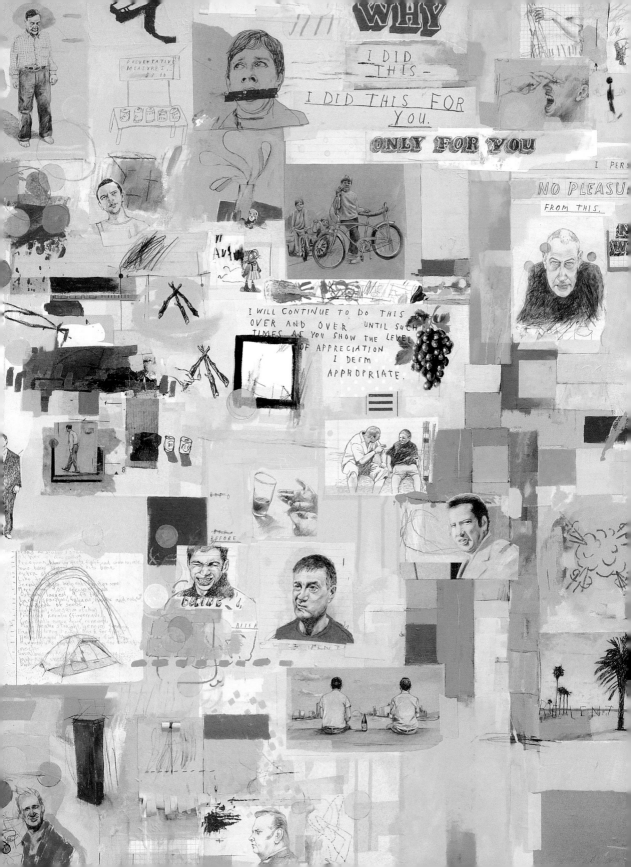

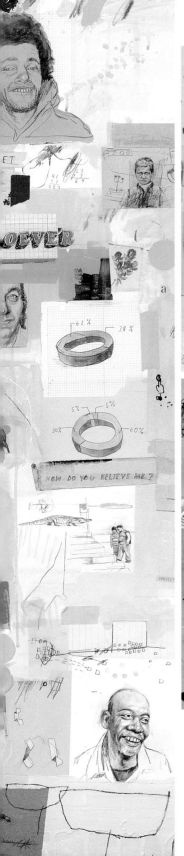

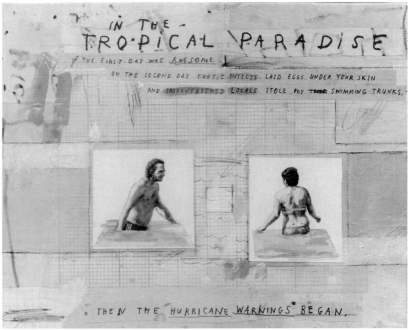

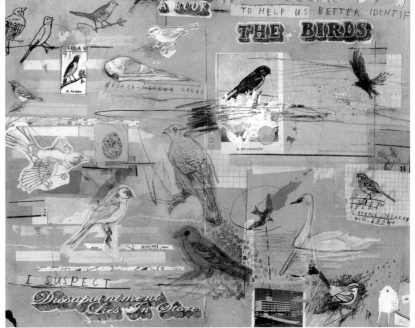

left: Artist Statement / right: top, Tropical paradise, bottom, Seeds Of Fate, **David Fullarton**

Lucila Dominguez

lucilismo.com

An Argentinean artist born in 1984 and based on Buenos Aires.

Muralist , painter, drawer and illustrator, nature and travel lover. Lucila creates images of great strength, colour and visual impact, deeply inspired on nature. Her speciality is botanic themed mural painting.

She is passionate about nature and particularly about the plant universe, the strength of their colours and shapes. Lucila feeds from these elements to create her own pictorial universe loaded with details and textures, with a delicate control of colour and light. Her painting is cheerful, expressive, with touches of mystery and surrealism and it unfolds a tireless search for beauty.

Artista argentina nacida en 1984, con sede en Buenos Aires.

Muralista, pintora, dibujante e ilustradora, amante de la naturaleza y los viajes. Lucila crea imágenes de gran fuerza, colorido e impacto visual inspiradas profundamente en la naturaleza. Su especialidad es la pintura mural de temáticas botánicas.

Apasionada por la naturaleza y en especial el universo de las plantas, la fuerza de sus colores y sus formas, Lucila se nutre de estos elementos para crear su propio universo pictórico cargado de detalles y texturas, con un delicado manejo del color y la luz. Su pintura es alegre, expresiva, con toques de misterio y surrealismo, y se despliega en una búsqueda incansable de la belleza.

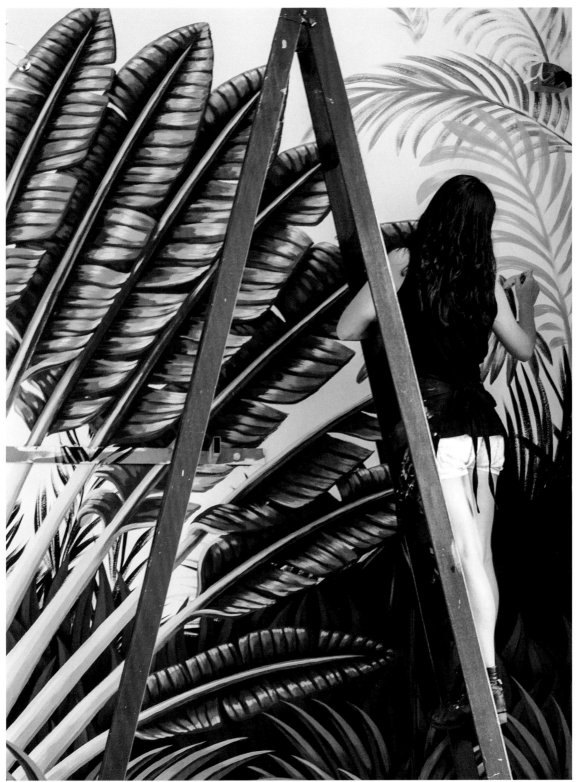

Traveler Palm, Lucila Dominguez

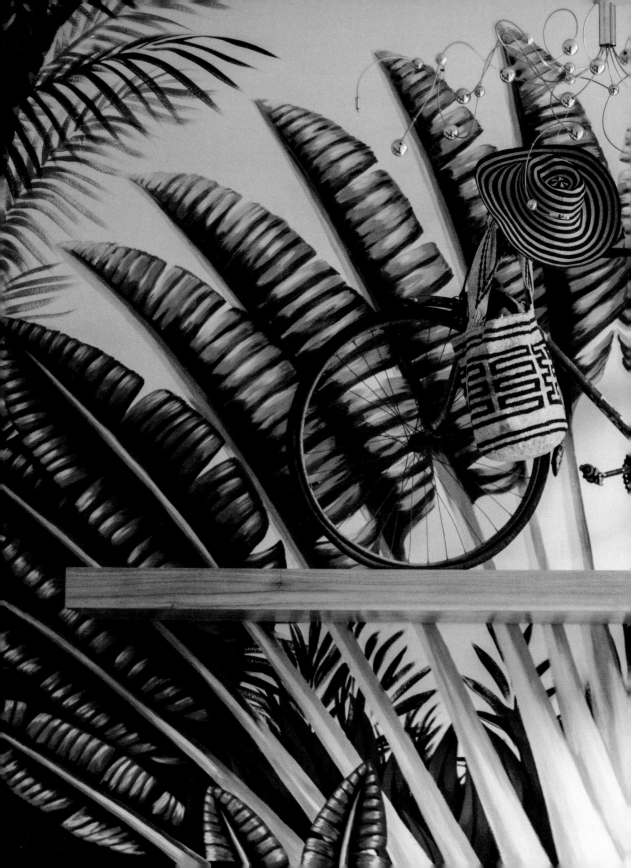

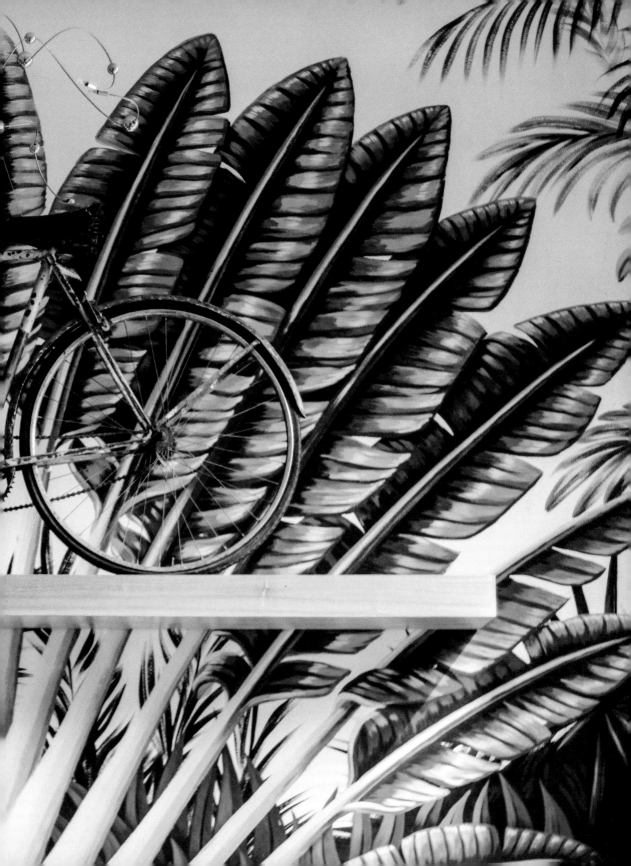

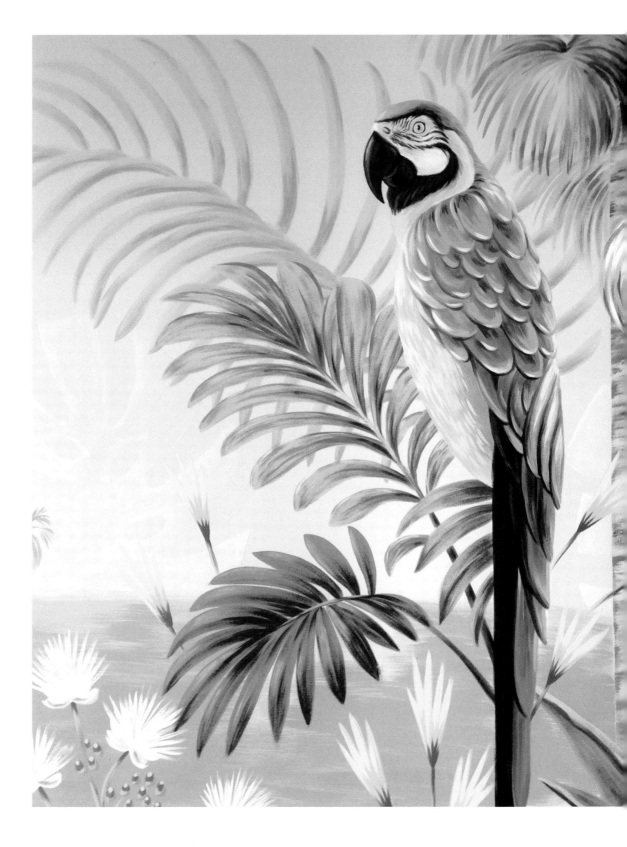

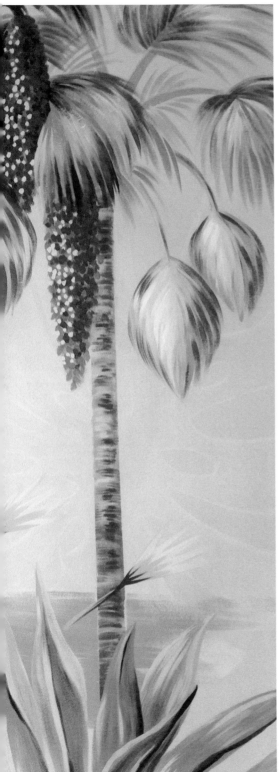

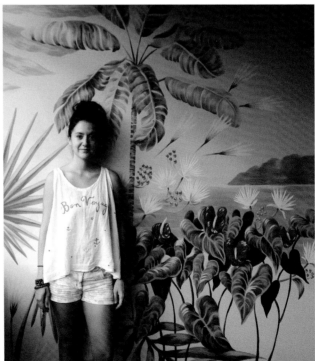

Brasilia, **Lucila Dominguez**

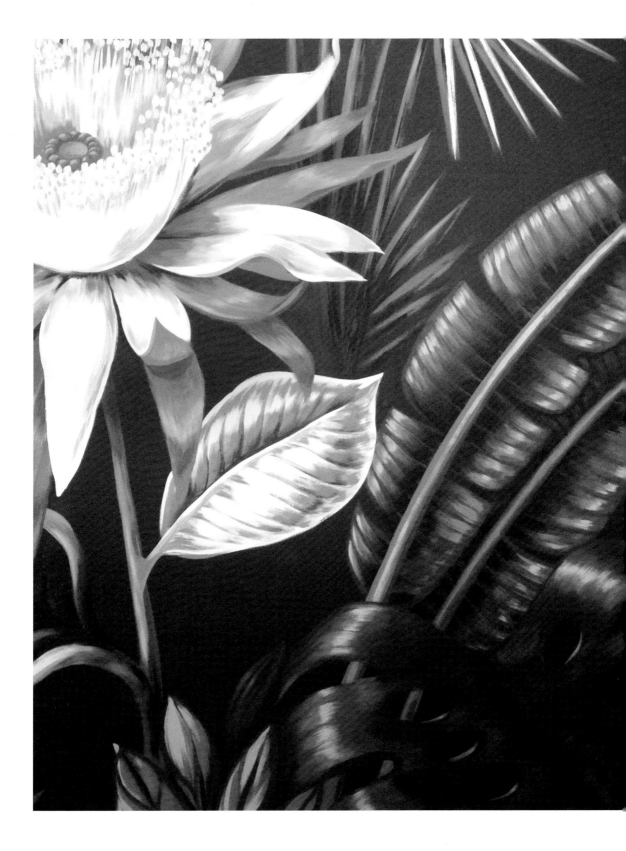

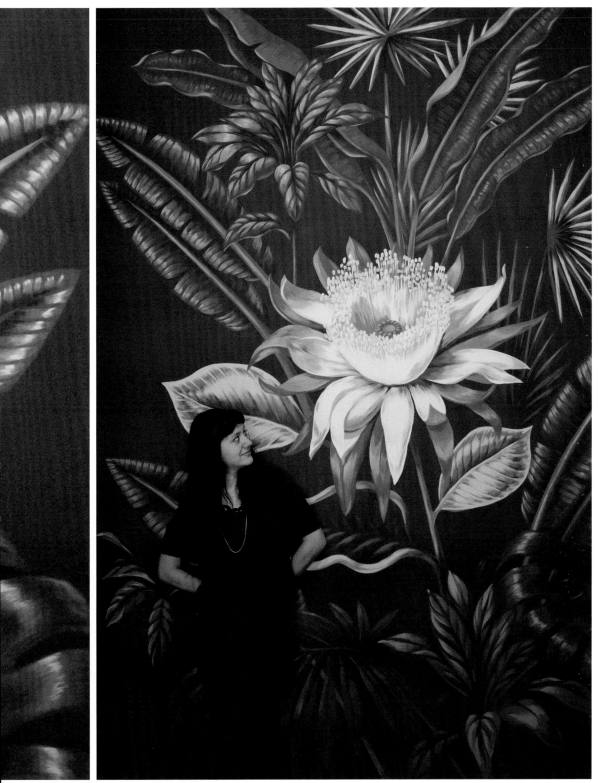

Princesa de la noche, **Lucila Dominguez**

María Laura Benavente Sovieri

www.mililitros.com

Buenos Aires 1979. Graduated on Fine Arts within the "Cultural Though and Prospective" itinerary at the La Laguna University. Currently her work is focused on contributing creative solutions to visual ideas, commercial photography, illustration, Prop Stylish, design of photographic sets, Papercrafts, art directing and everything that has something to do with photography and the creative world.

Buenos Aires 1979. Licenciada en Bellas Artes dentro del itinerario de "Pensamiento y prospectiva Cultural" por la Universidad de La Laguna. Actualmente su trabajo está centrado en aportar soluciones creativas a ideas visuales, fotografía comercial, ilustración, Prop Stylish, diseño de sets fotográficos, Papercrafts, dirección de arte, y todo lo que tenga que ver con la fotografía y el mundo creativo.

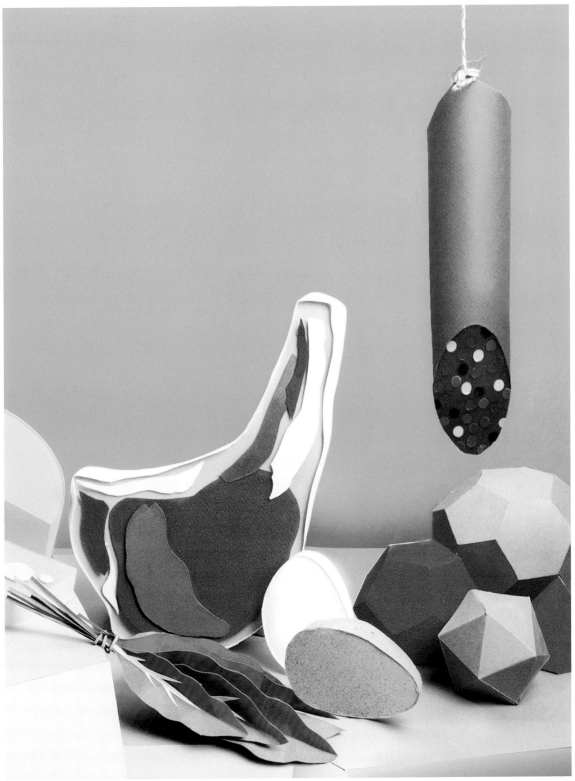

Die Zeit, María Laura Benavente Sovieri

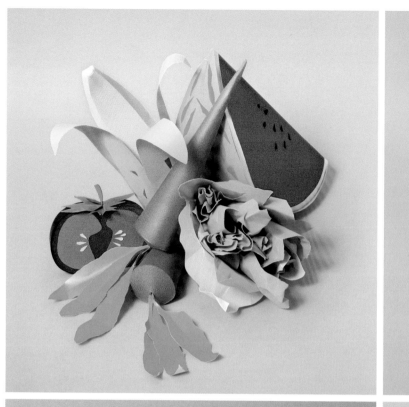
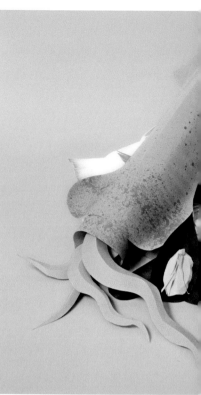
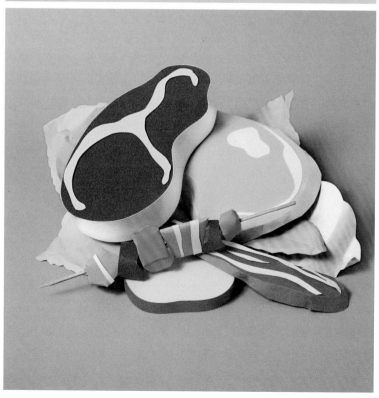
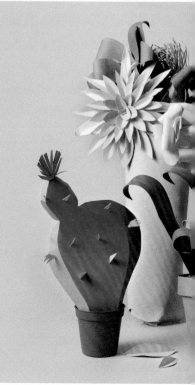

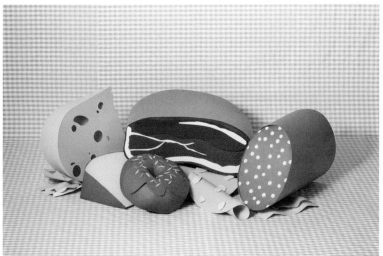

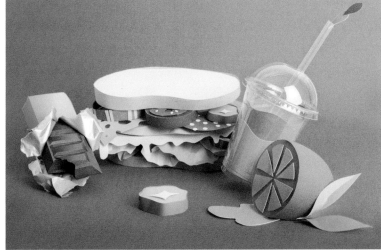

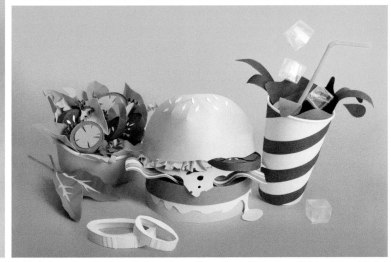

left: Mercado Central, **María Laura Benavente Sovieri** / right: top, El genuino sabor, bottom, Dutch railways, **María Laura Benavente Sovieri**

VWorkshop

www.vworkshop.com

VWorkshop is a collective of professional artists - designers brought together by a common creative expression. The team is run by the handmakers Marga López and Joan Tarragó. The group's main activity is bringing to life our creative language experimenting with several techniques and a wide variety of natural materials. Visual art is no longer bound by the flat format, but very often inspects and even develops space. With our projects we try to build bridges between art and design, where illustration, painting, street & communication all play an important role.

Joan illustrates his fantastic animal's world and characters, holy scenarios filled with symbolism and curious lines and textures. A ritual atmosphere ready to melt with typography and endless traces of organic lines growing fanciful.

Marga´s works turns into some sort of two-dimensional goldsmithing, due to the use of extremely fine lines and deft detail care. Illustration and graphic design come together in an overlapped system of frames, organic geometries and repeated modules, attaching great importance to typography.

VWorkshop es un colectivo de artistas profesionales –diseñadores unidos por una expresión creativa común–. El equipo está dirigido por los artesanos Marga López y Joan Tarragó. La actividad principal del grupo es dar vida a nuestro lenguaje creativo experimentando con varias técnicas y con una amplia variedad de materiales naturales. El arte visual no está ya limitado por el formato plano, si no que muy a menudo inspecciona e incluso desarrolla el espacio. Con nuestros proyectos tratamos de construir puentes entre arte y diseño, donde la ilustración, la pintura, la calle y la comunicación juegan un rol importante.

Joan ilustra su fantástico mundo animal y caracteres, escenarios sagrados llenos de simbolismo y de curiosas líneas y texturas. Una atmósfera ritual lista para fundirse con la tipografía y un sinfín de trazas de líneas orgánicas haciéndose fantasiosas.

El trabajo de Marga se convierte en una suerte de orfebre bidimensional, debido a su uso de líneas extremadamente finas y diestro cuidado del detalle. Ilustración y arte gráfico se unen en un sistema de marcos superpuestos, geometrías orgánicas y módulos repetidos, dando una gran importancia a la tipografía.

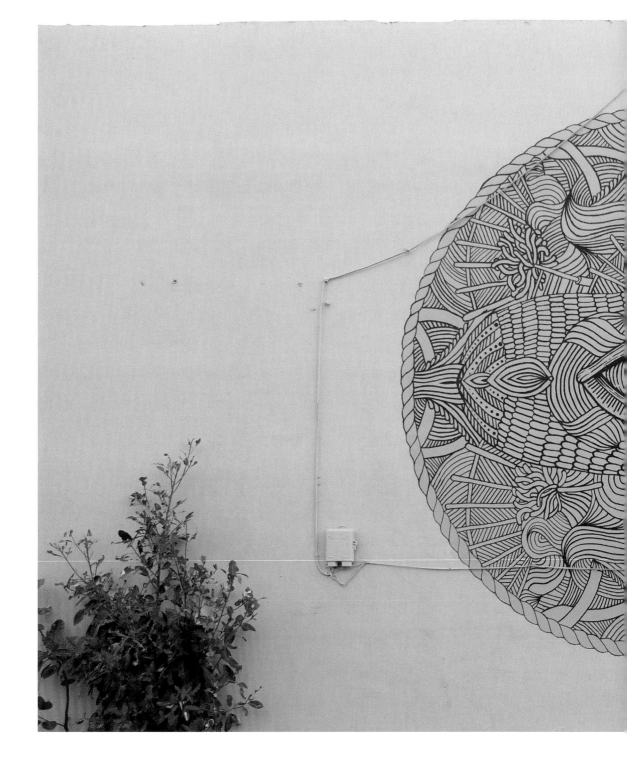

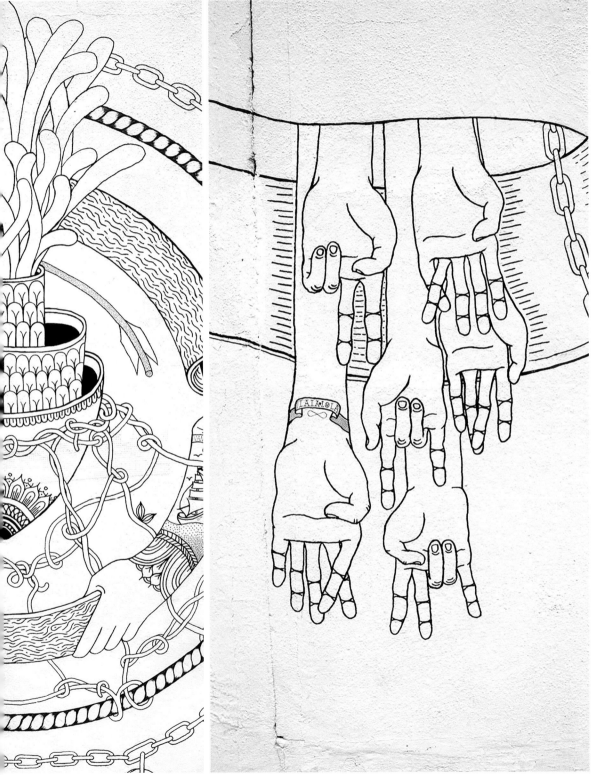

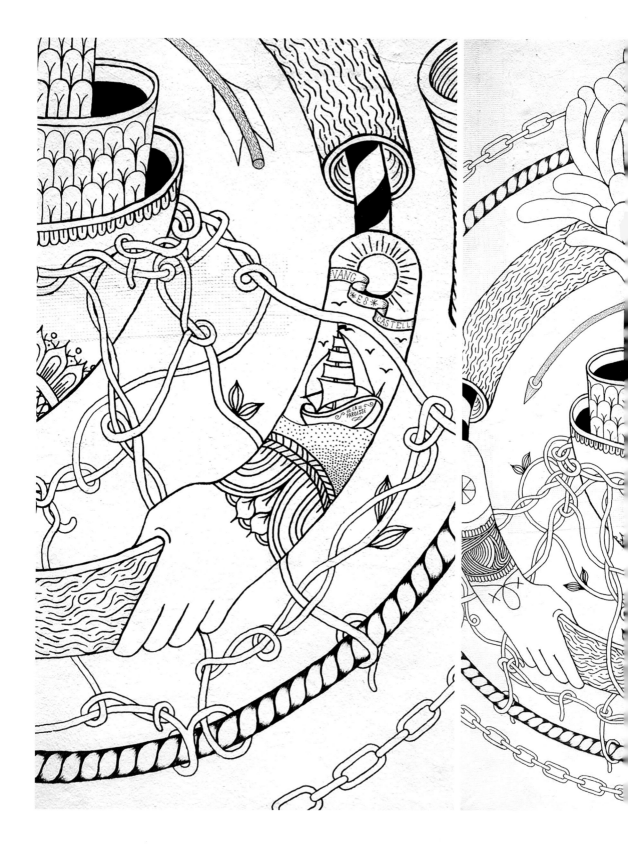

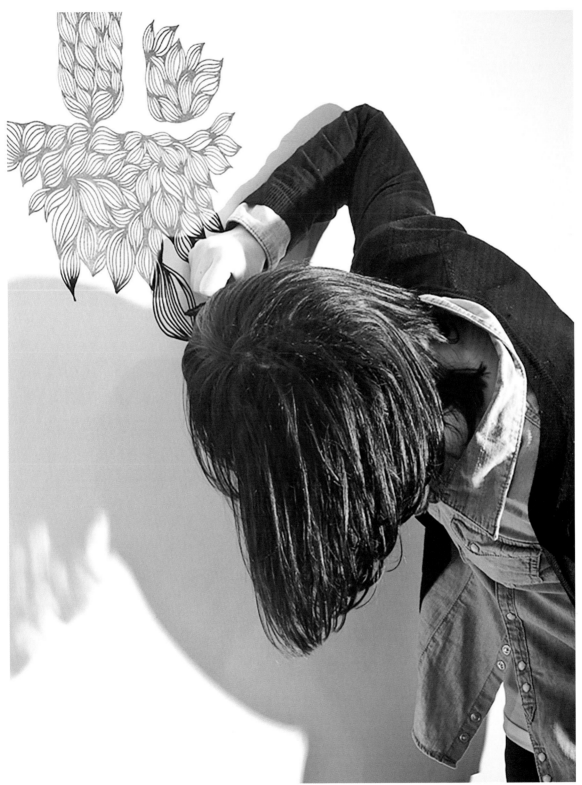

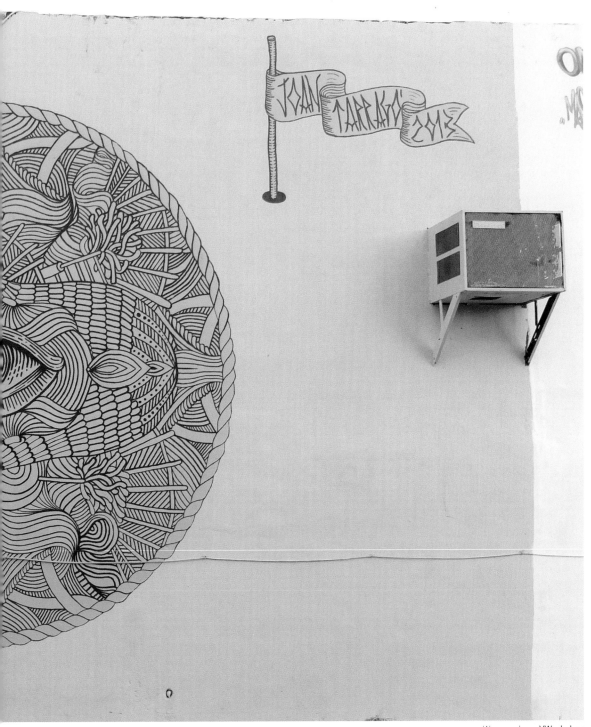

Ollanski

ollanski.com

Oliver a.k.a. Ollanski - an award-winning paper engineer and illustrator based in Berlin.

Back in 2008 he quit a PhD in molecular neurobiology at the Max Planck Institute in Berlin to pursue his passion for paper art.

Since then he has made hand-crafted paper objects for photographic and animated advertising campaigns of iconic brands like Ferrero, PlayStation and Pepsi and my work has been featured in publications like NYLON (US), brandeins (GER) and Ud&Se (DK).

He has been making art out of paper for as long as he can remember and my work is inspired by my passion for everything from biology to K-pop.

In an age of digital VFX and simulations, the ingenuity and versatility of his paper art gives his clients' advertising campaigns a real edge and an allure.

Above all, Oliver loves what he does. The biggest reward is watching people marvel at what a simple sheet of paper can be turned into!

Oliver a.k.a. Ollanski – Un premiado ingeniero en papel e ilustrador con sede en Berlín.

Allá por 2008 dejó un doctorado en neurobiología molecular en el Instituto Max Plank en Berlín para dedicarse a su pasión por el arte en papel.

Desde entonces ha hecho objetos de artesanía en papel para campañas publicitarias fotográficas y animadas de marcas icónicas como Ferrero, PlayStation y Pepsi y su trabajo ha aparecido en publicaciones como NYLON (US), brandeins (GER) y Ud&Se (DK).

Ha estado haciendo arte en papel hasta donde alcanza su memoria y su trabajo está inspirado en su pasión por todo, desde la biología al K-pop.

En una era de VFX digital y simulaciones, el ingenio y la versatilidad de su arte en papel dan a las campañas publicitarias de sus clientes un verdadero toque distintivo y encanto.

Por encima de todo, Oliver ama lo que hace ¡La mayor recompensa es ver a la gente maravillarse ante lo que se puede hacer con una simple hoja de papel!

Home Sweet Home (Cover for Swedish Nöjesguiden Magazine from February 2014), **Ollanski**

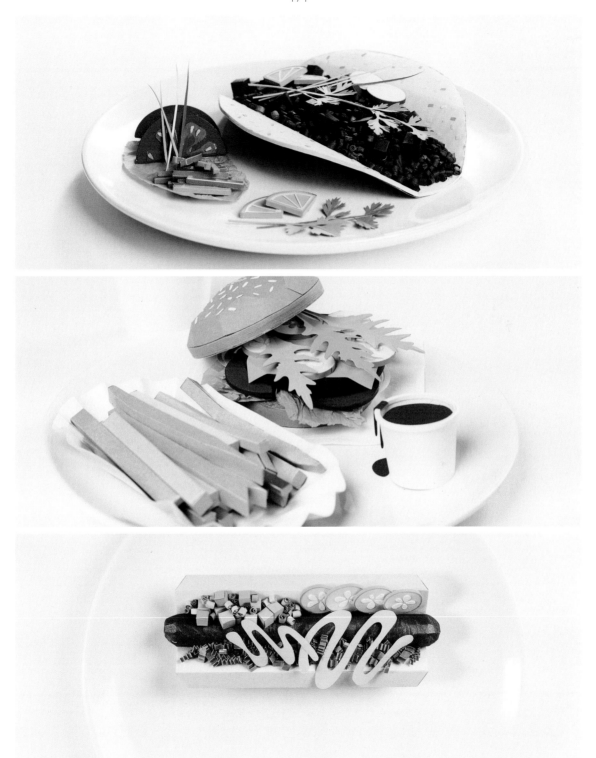

left: Instagram Thank You, **Ollanski** / right: Kids Food For Fine People (Fast Food Special in Nöjesguiden Magazine, 2013), **Ollanski**

left: Flowers (personal work, 2015), **Ollanski** / right: top, Flyer for KangaROOS 2014, bottom, Medalzz - personal work, 2015 **Ollanski**

Anna Khokhlova

www.behance.net/annaxoxlova

Anna Khokhlova graduated from Moscow State University of Printing Arts with a major in Graphic Design and British Higher School of Art and Design with a major in Illustration. She is also a part of community of illustrators called TZEH. Working in many fields of design including stage design, prints, illustration and photography.

She treats book illustration as stage design. Each book, like each play, dictates it's own illustration style. When she came across "Cockerel" by her favorite author Alexey Remizov, she got an idea of making very warm and cozy illustrations for that text. The book won the first prize in all-Russia competition of book illustration "Obraz knigi". It looks like a children's book while the text is very complex and tragic - it is a story about a family on the verge of the Russian revolution of 1917. That is probably the reason why it is not published yet.

After that she started getting a lot of positive reviews for the book and requests for embroidery illustrations. Her favorite works were made for the cover of BOLSHOY GOROD's magazine (it's a bit like New Yorker in New York), illustrations for "PRIME RUSSIA" (the biggest russian publication on art, sociology and philosophy). She also got short-listed in D&AD competition in London. Her current projects employ a different style of illustration (She published 2 children's books recently). She also teaches illustration in Moscow.

Anna Khokhlova se graduó en la Universidad Estatal de Moscú de Artes Impresas especializándose en Diseño Gráfico y en la British Higher School de Arte y Diseño especializándose en Ilustración. También es parte de una comunidad de ilustradores llamada TZEH, trabajando en numerosos campos del diseño, incluyendo diseño de escena, impresión, ilustración y fotografía.

Trata la ilustración de libros como diseño de escena. Cada libro, como cada obra, dicta su propio estilo de ilustración. Cuando trabajó con "Cockerel" de su autor favorito, Alexey Remizov, tuvo la idea de hacer una ilustración muy cálida y amigable para ese texto. El libro ganó el primer premio en la competición de ilustración de libros a nivel de toda Rusia "Obraz Knigi". Tiene la apariencia de un libro de niños mientras que el texto es muy complejo y trágico —es la historia de una familia al borde de la Revolución Rusa de 1917—. Esta es probablemente la razón por la que todavía no ha sido publicado.

Después de aquello, empezó a tener muchas reseñas positivas por el libro y a recibir encargos para ilustraciones de bordado. Sus trabajos favoritos se hicieron para la portada de la revista BOLSHOY GOROD (que es un poco como el New Yorker en New York), ilustraciones para "PRIME RUSSIA" (la mayor publicación de arte, sociología y filosofía rusa). También fue seleccionada en la competición D&AD en Londres. Su proyecto actual emplea un estilo de ilustración diferente (publicó 2 libros infantiles recientemente). También enseña ilustración en Moscú.

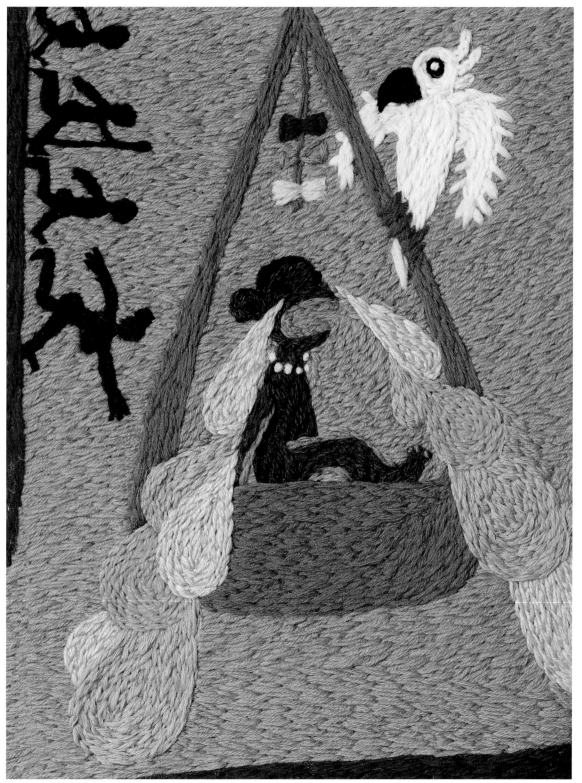

Illustration for Prime Russia magazine, **Anna Khokhlova**

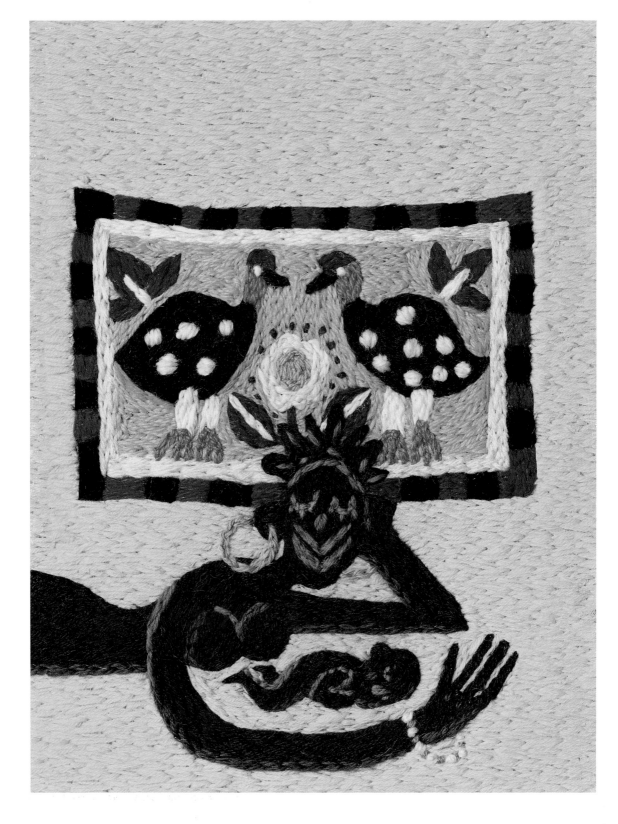

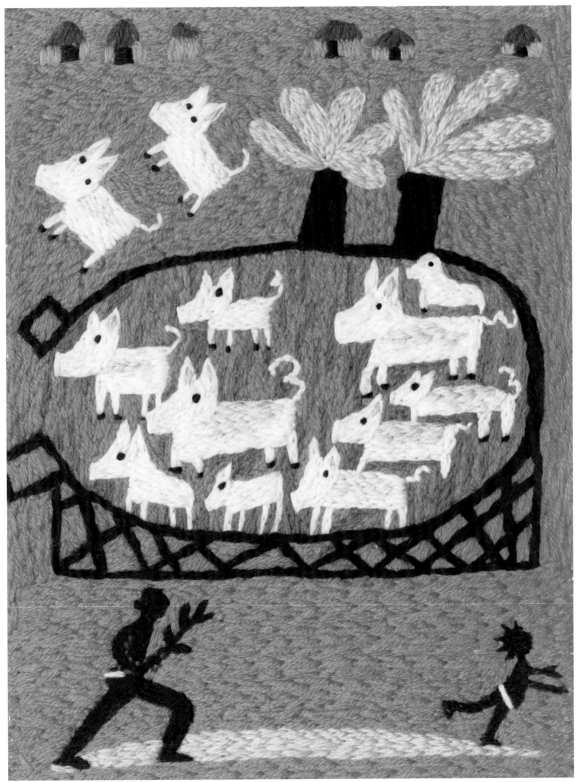

Illustration for Prime Russia magazine, **Anna Khokhlova**

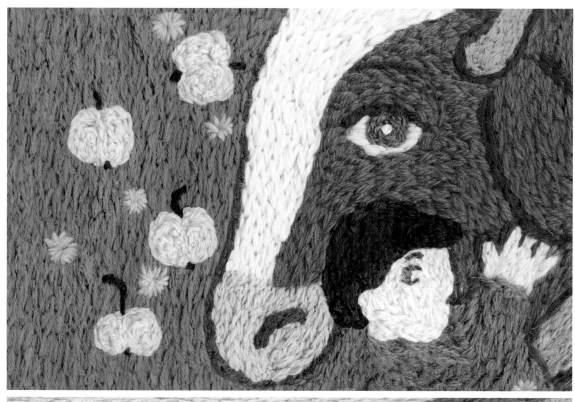
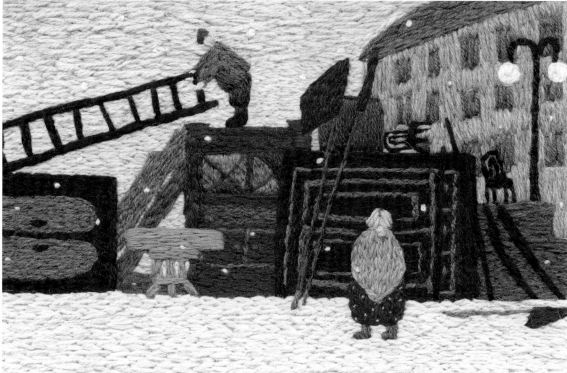

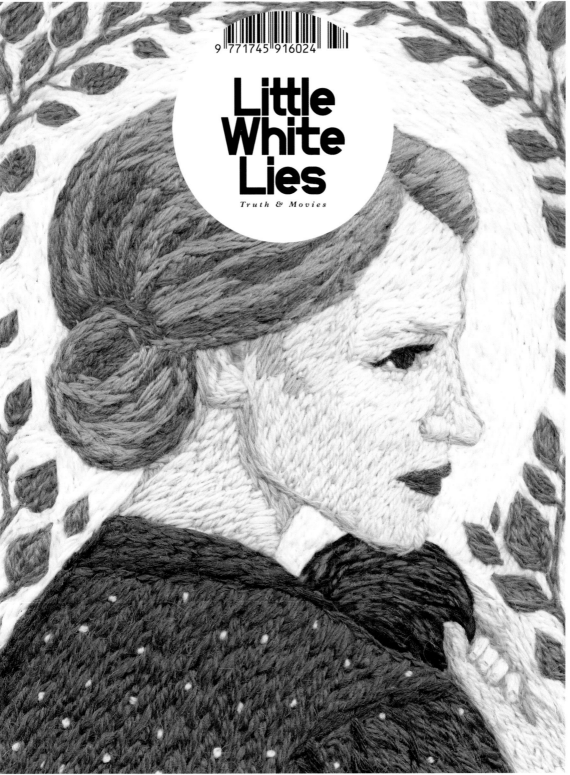

Little
White
Lies

Truth & Movies

left: Cockerel book, **Anna Khokhlova** / right: Cover of magazine Little White Lies, **Anna Khokhlova**

Olga Ezova-Denisova

ezovadenisova.ru
ezovadenisova.blogspot.com

Olga Ezova-Denisova — artist and illustrator from Russia (Ural, Ekaterinburg).

She works in printmaking techniques such as linocut and stamps from linoleum, fabric block printing. Also she creates illustrations in the collage, where she uses paper and/or textile, embroidery, drawing and stamps.

"Lately my favorite theme for imaging is a nature. I love to find twigs, cones and various plants in a forest and then I try to reproduce them using linoleum, cutters and printing ink. I love paper and fabric equally but textile work needs more force. I try to imprint not only the form and color, but also the mood and spirit. This is a mood that I felt when I saw these plants. Or this is a mood by which I noticed exactly these branches".

Olga Ezova-Denisova, artista e ilustradora rusa (Ural, Ekaterimburgo).

Trabaja en técnicas de confección de estampados como linograbado y estampación de linóleo, estampación de tela en bloque. También crea ilustraciones en collage, donde utiliza papel y/o textil, bordado, dibujos y estampados.

"Últimamente mi tema favorito para las imágenes es la naturaleza. Me encanta encontrar ramitas, piñas y distintas plantas en un bosque y entonces tratar de reproducirlas usando linóleo, cúteres y tinta de impresión. Me encantan el papel y la tela por igual pero el trabajo en textil necesita más fuerza. Intento imprimir no solo la forma y el color, pero también el ánimo y el espíritu. Este es el estado de ánimo que siento cuando veo estas plantas. O este es el estado de ánimo por el que me fijo en estas ramas exactamente".

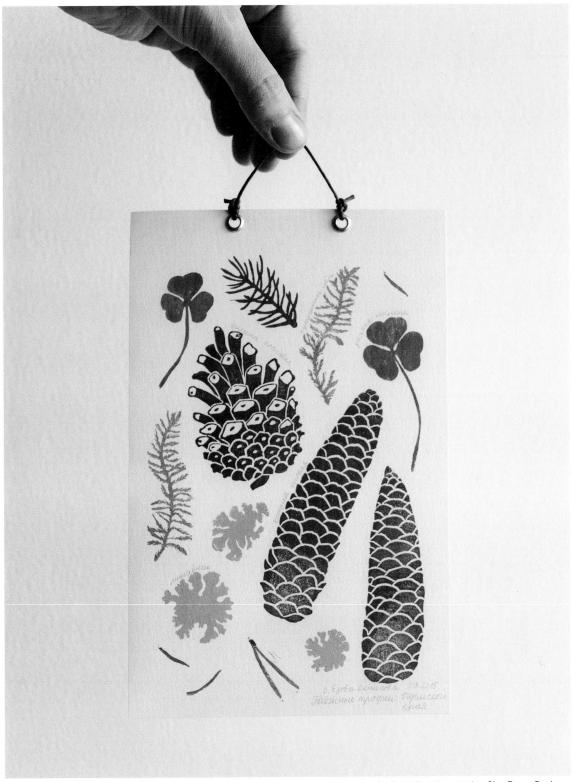

Illustration for Prime Russia magazine, **Olga Ezova-Denisova**

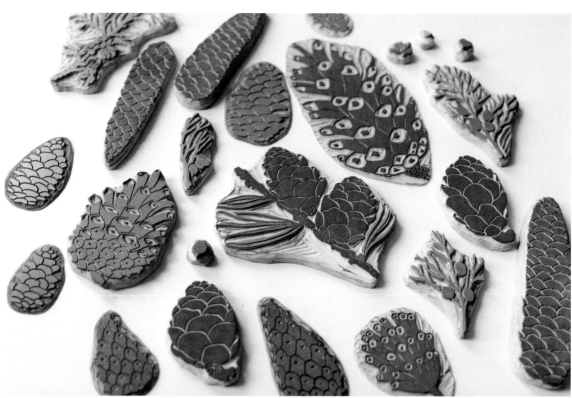

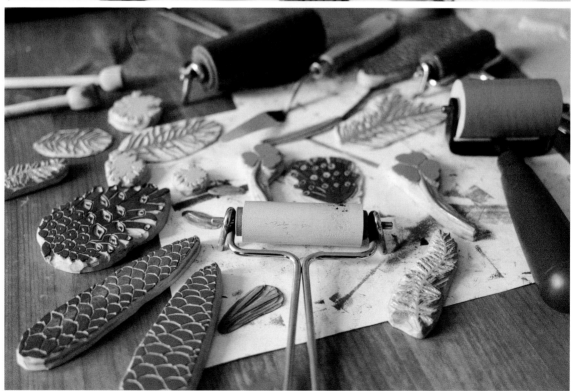

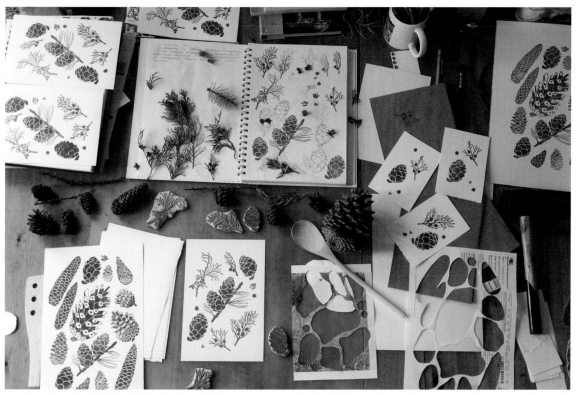

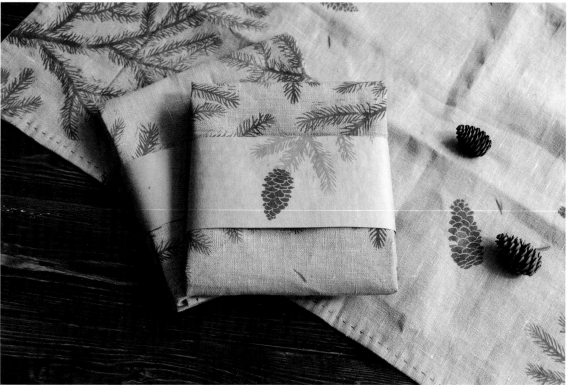

Óscar Lloréns

www.oscarllorens.com

As any illustrator, Oscar Lloréns has always liked drawing. His beginning as a professional drawer started in the year 2005 when he left the world of publicity to start a career as a freelance. He has always drawn as a hobby, from an early age, but, getting in contact with publicity, he discovered the figure of the illustrator, unknown to him until then.

He feels at ease making murals since making a mural allows for certain experiences that a paper or a computer cannot give him, even though it requires more resources in every sense.

Como cualquier ilustrador, a Óscar Lloréns siempre le ha gustado dibujar, sus comienzos como dibujante profesional empezaron en el año 2005 al dejar la publicidad para empezar una carrera como freelance. Siempre ha dibujado como afición, desde muy joven, pero al entrar en contacto con la publicidad descubrió la figura del ilustrador, hasta ahora desconocida para él.

Se siente muy a gusto haciendo murales, ya que hacer un mural le permite determinadas experiencias que un papel o un ordenador no pueden darle, aunque también requiere más recursos en todos los sentidos.

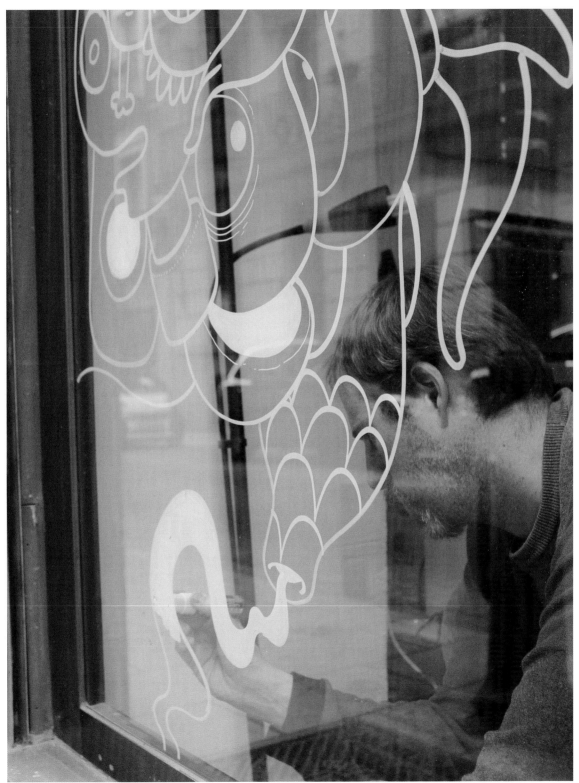

Óscar Lloréns

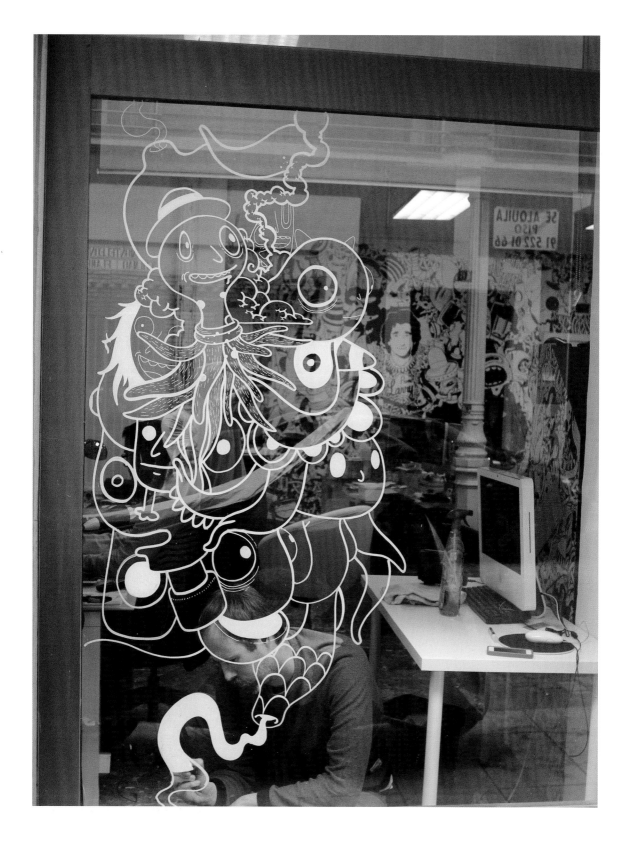

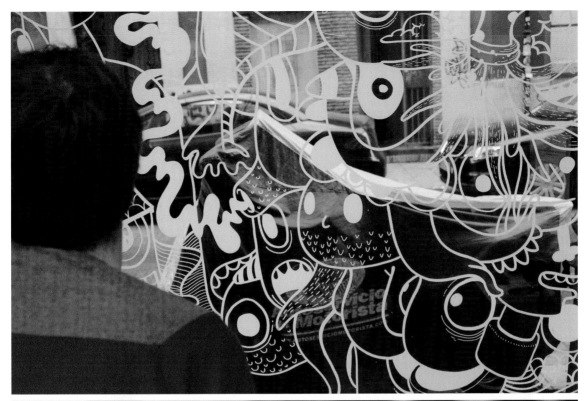

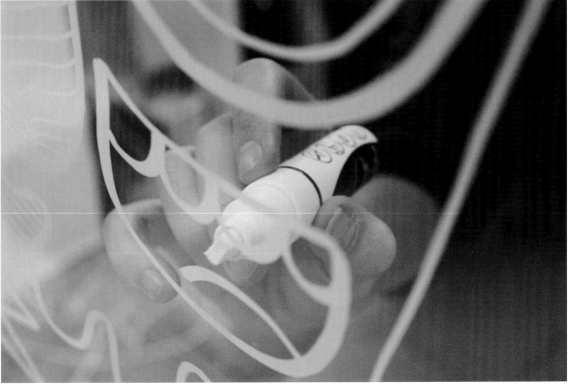

Escaparate estudio "Primo Larry", **Óscar Lloréns**

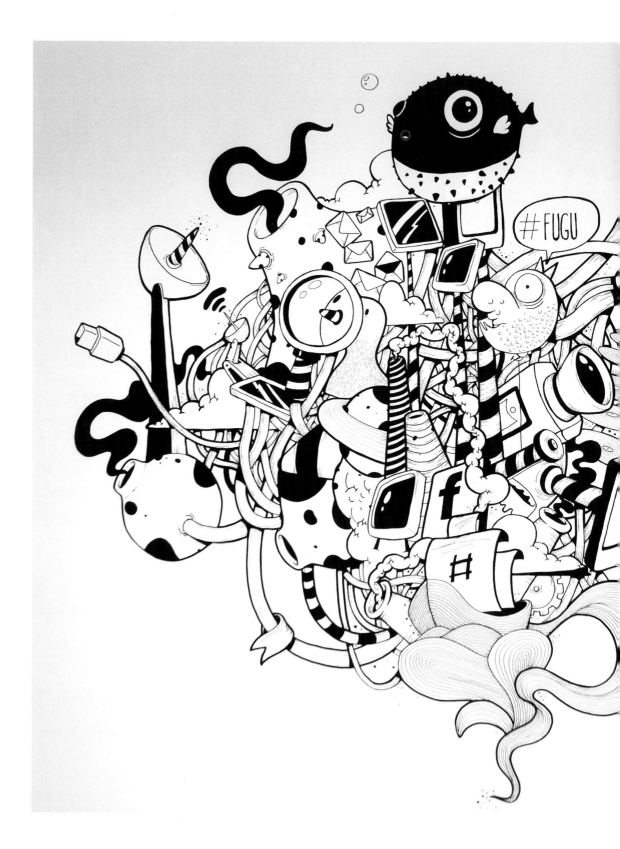

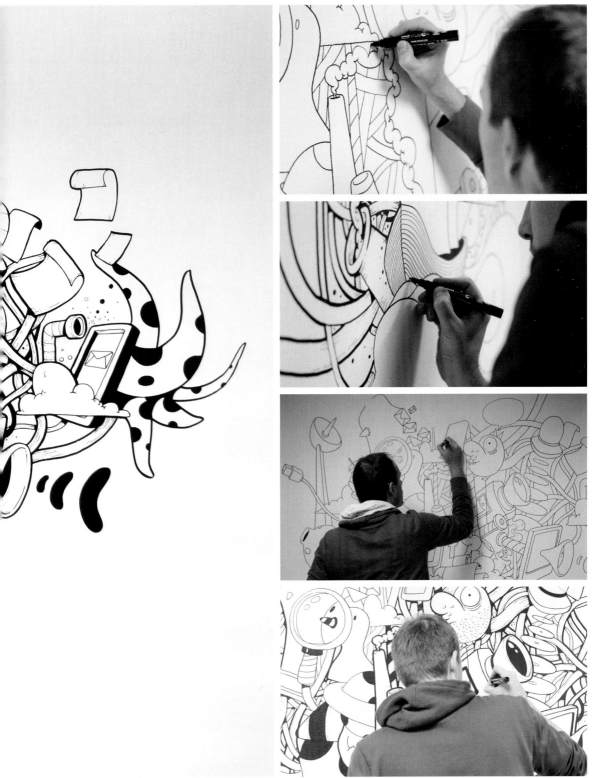

Mural agência Fugu, **Óscar Lloréns**